IMAGES
of America

REDMOND

WASHINGTON

CERTIFICATE OF INCORPORATION OF REDMOND, KING COUNTY,

STATE OF WASHINGTON, INTO A TOWN OF THE FOURTH

CLASS.

- - - - - - - - - -

This is to certify that in response to a petition signed by over sixty residents of Redmond, King County, Washington, filed with the Board of County Commissioners of said King County, on the 3rd day of December, 1912, asking for the incorporation of said Town of Redmond into a Town of the Fourth Class, due and legal notice of such filing having previously been given, an election was called by said Board of County Commissioners to be held on the 23rd day of December, 1912, within the boundaries of said proposed incorporation for the purpose of determining the advisability of incorporating said town of Redmond into a town of the 4th class and for the election of officers to govern said town in the event of said incorporation. Due and legal notice of such election having been given by publication, and it appearing to the full satisfaction of the Board of County Commissioners that all proceedings heretofore had in this matter were legal and in accordance with law governing such matters, and the election having been held in due form, the Board of County Commissioners did on the 30th day of December, 1912, being the first Monday succeeding said election, proceed to canvass the vote cast with the following result:-

 For Incorporation, - - - - - - - - - - - - - - -94 votes.
 Against Incorporation, - - - - - - - - - - - - - 9 "
 For Mayor:
 F. A. Riel - - - - - - - - - - - - - - - - - 89 "
 For Treasurer:
 C. A. Shinstrom - - - - - - - - - - - - - - - 89 ""
 For Five members Municipal Council:
 Henry Weiss- - - - - - - - - - - - - - - - - - 88 "
 C. R. Kern - - - - - - - - - - - - - - - - - - 91 "
 Theo Youngerman- - - - - - - - - - - - - - - - 91 "
 Ed Majors - - - - - - - - - - - - - - - - - - -89 "
 A. G. Adams - - - - - - - - - - - - - - - - - -88 "
 J. H. Woodide - - - - - - - - - - - - - - - - - 3 "

 At the conclusion of said canvass, the Board did then

FILE No. 1

The City of Redmond celebrates its 90th Anniversary on New Year's Eve, 2002. They needed 300 residents to incorporate, otherwise the local option to tax saloons would have expired. They also needed to incorporate to create a water system to help defend fires. Ernest Alexander Adams, born on November 24, 1912, was the 300th resident. The following day meetings were held to begin the process of incorporation.

2

IMAGES
of America

REDMOND
WASHINGTON

Georgeann Malowney

ARCADIA
PUBLISHING

Published by Arcadia Publishing
Charleston, South Carolina

Printed in the United States of America

Library of Congress Catalog Card Number: 2002106380

For all general information contact Arcadia Publishing at:
Telephone 843-853-2070
Fax 843-853-0044
E-Mail sales@arcadiapublishing.com
For customer service and orders:
Toll-Free 1-888-313-2665

Visit us on the Internet at www.arcadiapublishing.com

(cover) *Entering the Hotel Redmond, from left to right, is Hazel Smith, Anna Smith or Emma White, and William Smith. This photograph was taken c. 1905.*

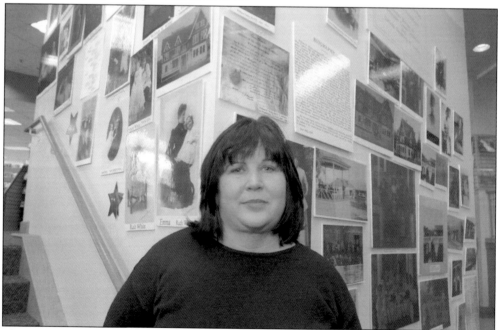

The City of Redmond approved a grant to display historical photos at Redmond Town Center, site of the original Luke McRedmond homestead. The assistance and desire of many people resulting from the displays was the impetus for this book. Photograph courtesy of *Seattle Times*, Ron Wurzer.

CONTENTS

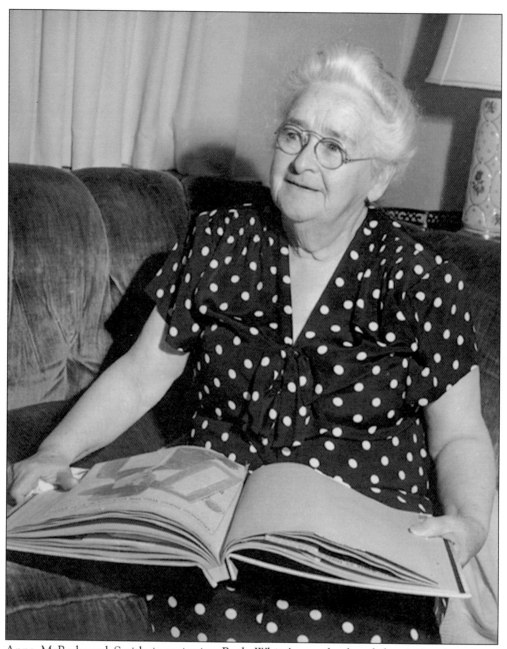

Anna McRedmond Smith is reviewing Ruth White's scrapbooks while visiting her niece, Dorothy White Hanscom, in 1949. This book is best thought of as a scrapbook of assorted photographs. It is not intended to be a comprehensive history. The author welcomes corrections and additional information, particularly relating to the identification of the people pictured herein.

ACKNOWLEDGMENTS

Ruth Sires Adams, Betty Buckley Anderson, Kurt E. Armbruster, Brad Best, Roy Buckley, Jon Haydock, Jenine Christensen, Annie Cikler, Penny Clark, Sally Drew, Violet Green Cook Elduen, Eric Erickson, Robert E. Ficken, Meagan Gillis, Valerie Gillis, Ruthanne Hayes Haight, David R. Harder, Helen Bennett Johnson, Euclid LaBrie, Ann Lamb, Daryl Martin, Ward Martin, Doris Hebner McFarland, John J. Miglino, Dante Morelli, Panfilo Morelli. Debby O'Donnell, Fredi Perry, Woody Reed, Robin Robinette, Patsy Cook Rosenbach, Doris Schaible, Harvey and Anne Tollfeldt, Helen Ottini Usibelli, Rose Weiss, Margaret Evers Wiese, Patti Simpson Ward, Nancy Way, Davy Winkle.

Katherine Barker, descendent of Mary Louie; Patricia Eacrett Turple, Laura Crews, Martha Hanscom, Diana Gardner Morelli, Ray Gardner, Aloysius Eugene O'Flaherty III, Mary Monica Sewell, M. Suzanne Roland, Florine Alexander, McRedmond descendents; Colleen Tosh Willis, Kris Underhill, Charlene Johnston Sugden, Robin Perrigo Norton, Dusty Watts Blair, Perrigo descendents; Ray Adams, Marilyn Pierce Adams, R.F. Larson, Dora Johnson, Ernest Adams' descendents; Roy Lampaert, Marilyn Lampaert Moesch, Adile Lampaert's descendents; Al and Helen Brown, Helen Wright Nichols, relatives of Mayor Bill Brown; Gladys Alsin, Terri Tollefson Gordon, Conrad Olsen's descendents.

Jim Russell, St. John's Lodge of Free and Accepted Masons of Washington, William E. Smith, Grand Lodge of Free and Accepted Masons of Washington; Sandy Grimm, Bonnie Watson Funeral Home, Phil Stairs, Washington State Archives; Gary Zimmerman, Pioneer Association of Washington; Heather McClelland-Wieser, Seattle Public Library; Sally Polk, King County Library; Elaine Miller, Joy Werlink, Washington State Historical Society; Boyd & Irene Reil Keeney, Jan and Diane Patty Foreman, Carol Hartwell, Fire Department Archives. Jackie Morris, Tom Hitzroth, Lillian Zigler, Mardy Call, Lillian Garland, Peggy Hansen, Mary Ellen Piro, Heather Trescases, Beth Zeitlin, Eastside Heritage Center; W. John Loacker, Kroll Map Company; Pamela Kruse-Buckingham, Kitsap Historical Museum.

Dori Haack, Sam and Mary Smith, Becky Winslow, Hotel Café Reunion; Sherry Grindeland, Ron Wurzer, Seattle Times. Lori Varosh, Patti Payne King County Journal. Kim Nichols, Eastside Genealogy Society; Mark Hoover, Jill Prestegard, Redmond Stake Center; Redmond Historical Society; Dianna Broadie, Richard Cole, Sharon Dorning, Jacky Goren, Patrick Hirsch, Rosemarie Ives, Nancy McCormick, Greg Misener, Kathie Murray, Thomas Paine, Holly Plackett, and Jim Robinson, City of Redmond; Adam Leader, Microsoft; Liz Neff, Shelly Clift, Borders Bookstore; Kathy Dufert, Bonnie, Lakeside Drugs; Kelly Gast, Macherich; Vince Cronin, Mailbox and Shipping Center; Rick Tupper, Marriott; and most of all Sarah Wassell, Arcadia Publishing.

Photographic Credits

Doris Hebner McFarland; Joan Appleby, Redmond Jr. High; Jan Foreman, Microsoft; Eagle Rim Apartments; Eastside Heritage Center, Snoqualmie Tribe; University of Washington. Most photographs were provided by descendents of the Adams, Lampaert, McRedmond, Morelli, Perrigo and pioneer families named above. Some of the early pictures were photographed by E.J. Bailey, pages 15, 80; Boyd and Braas, page 24; Bushneff, pages 34, 42, 42; E.A. Clark, page 9; Darius Kinsey, page 18; Theodore E. Peiser, page 22; F. La Roche, Spalt, page 22; and Winifred Wallace, pages 72, 90, 97, 120, 122. Some 20th Century photographers: Asahel Curtis, page 84; Bob Bailie; Larry Stair; Chuck Lee; *Sammamish Valley News*, pages 77, 78; Ron Wurzer, Seattle Times, page 4.

INTRODUCTION

The Territory of Washington was created by an Act of Congress on March 2, 1853. Washington Territory's first governor, Isaac Stephens, arrived in late 1853 with one overriding mission: negotiate treaties that would remove Indian tribes from most of their ancestral lands. At the conclusion of several major treaties in 1854 and 1855, some natives raided farms and whites retaliated. There was the daylong attack on Seattle led by Chief Leschi.

Port Madison and Teekalet were small struggling sawmill towns, manufacturing lumber for the San Francisco market. Except where a clearing of a few acres in the forest was made on the shoreline for a town-site, practically the whole of Puget Sound country was heavily timbered with dense forests and without roads, and the travel from one settlement to another was, of necessity, by water. Salmon Saltery and other maritime suppliers did a brisk trade. Coal was discovered south and east of Seattle and would soon become another valuable export. In 1855, money was appropriated for construction of a road from Vancouver to Fort Steilacoom. In 1857, further funding extended the road northward to Fort Bellingham.

In 1857, Slaughter County was organized and named for Lieutenant W.A. Slaughter who had been killed in battle in the Indian Wars of 1855–56. Luke McRedmond was a broad and public-spirited man and was closely identified with the more prominent movements of the political affairs of his community and state, adhering all his life to the principles of the Democratic Party. In 1857, he ran for legislative representative for Slaughter County (later renamed to Kitsap County) and was a member of the convention that nominated General Isaac Stevens to be the first delegate to represent the Territory of Washington in the Congress of the United States. Luke held numerous offices in Kitsap County: county auditor and clerk of courts (1858); county assessor (1859); county commissioner (1864–7); and road supervisor, district 2 (1867). Luke was also sheriff, clerk of elections, grand juror, and a road viewer in Bainbridge Island.

A trail, and in parts a road, had been opened through to Fort Bellingham over which support to Captain George E. Pickett (later the Confederate general who led the famous infantry charge at Gettysburg) had been conducted, to tell the British lion in July 1859, in face of superior force, that the Stars and Stripes would continue to wave over the San Juan group of islands.

In 1860, there was "once-a-week" U.S. mail between Olympia and Seattle. The mail contractor had the option of carrying it by land or water. News of Abraham Lincoln's election and the Civil War took up to three weeks to reach the pioneers by steamer or horseback.

In 1860, the population of Washington Territory was less than 12,000. Olympia and Steilacoom were the principal towns on Puget Sound. Whatcom, now called Bellingham, had quartered many thousands of miners and prospectors from California during the Fraser River gold excitement in 1858, but with the transfer of the base of supplies to Victoria, had sunk back to a small settlement.

The little hamlet of Seattle was still a sparsely settled and inaccessible country, the population of which, according to the 1860 census, was 250, including 20 families. All of King County had a population of 302, with the addition of 52 white people outside of Seattle. There were no railroads within 1,500 miles or more. Sailing vessels and an occasional steamer operated between San Francisco and Seattle were the only communication with the outside world, except by Pony Express and ox-team.

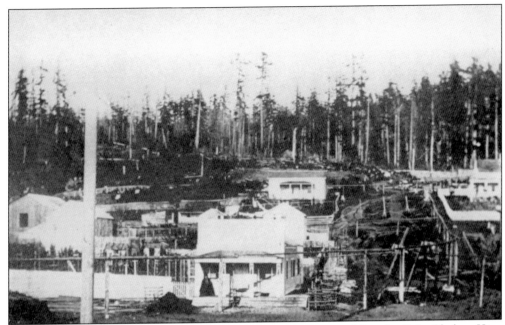

This photo is said to be one of the earliest surviving images of Seattle. E.A. Clark, a King County Auditor, was the photographer. Sarah Yesler, wife of future mayor Henry Yesler, stands on the front porch of their white house. Henry Yesler had arrived in the area in October 1852 to build Puget Sound's first steam-powered sawmill. Two months later King County was created on December 22, 1852. The elevated wooden flume that carried water to the city from a hillside spring is toward the right side of the picture. Some trees remained in the dense forest that covered the area. The Butler Cottage facing James Street is immediately behind the Yesler Home. On November 7, 1858, Hillary Butler, a wealthy Seattle citizen, purchased from Henry Yesler two lots on the northwest corner of James and Second Avenue. Hillary Butler's home was always known as a home of warm Virginian hospitality. It is probable that the first meeting of St. John's Lodge met here, since Mr. Butler was a founding member. Judge William H. White lived at the Butler Cottage when he first came to Seattle in 1871. White would later become Master of St. John's Lodge, No. 9, in Seattle after which on June 6, 1884, he was elected Grand Master of the Masons of Washington Territory. Many people who later settled in what became Redmond previously lived or worked near Yesler's mill. According to Fredi Perry, the renowned Kitsap County author in *Kitsap: Centennial History*, "After the Indian Wars of 1856, those abandoning King County properties for jobs at the Port Madison mill were Luke McRedmond, Timothy Hinckley, Edward Hanford, Joe and Arnold Lake, George King, Charles E. Brownell, Tim Grow, and E.A. Clark. The Luke McRedmond family later moved back to Seattle in 1869. In 1866, Warren Wentworth Perrigo arrived with his young bride Laura on one of the Mercer ships carrying his famous "cargo of brides." Warren worked at the Yesler mill and also taught school in Kitsap County before moving to what became Redmond in 1871. Jim Graham was a Snoqualmie elder who worked for Mr. Yesler but lived near Redmond. During the earliest days of the Sammamish Valley's settlement most pioneers traveled to Seattle for dry goods, mail, church, Providence Hospital, and funerals.

Some early settlers to the Eastside worked in Seattle part of the year and managed their farms on the Eastside part of the year. As people learned of the opportunities east of Lake Washington, more settlers came to take advantage of the Homestead Act. Between 1870 and 1890 the number of farms in the United States rose by nearly 80 percent. Railroad expansion peaked between 1879 and 1883, and opened new areas to agriculture, linking these to rapidly changing national and international markets. Mechanization, the development of improved

crops, and the introduction of new techniques increased productivity and fueled a rapid expansion of farming operations. The output of staples skyrocketed. Grain and fiber flooded the domestic market.

The depression of 1893–1897 was one of the worst in American history with the unemployment rate exceeding ten percent for half a decade. The depression, which was signaled by a financial panic in 1893, has been blamed on the deflation dating back to the Civil War, the gold standard and monetary policy, and under-consumption. The financial crises of 1893 accelerated the recession that was evident early in the year into a major contraction that spread throughout the economy. An extensive but incomplete revival occurred in 1895.

William Jennings Bryan's Democratic nomination for the presidency on a free silver platform the following year was amid an upsurge of silverite support. William Jennings Bryan's visit to Redmond to confer with Judge William H. White, chairman of the Washington delegation for Democrats, must have been a very special day. Only in mid-1897 did recovery begin in this country; full prosperity returned gradually over the ensuing years.

In 1897 news of a gold strike in the Canadian Yukon reached Seattle, triggering a stampede north to the Klondike Gold Fields. From 1897 to 1898, tens of thousands of people from across the United States and around the world descended upon Seattle's commercial district. While in Seattle, the hopeful miners purchased millions of dollars of food, clothing, equipment, pack animals, and steamship tickets.

Life in Norway and Sweden was tough during the global depression of the 1890s. Many frustrated young Scandinavians came to America to homestead or work in lumbering jobs. Many were attracted to an area in Redmond called "Happy Valley" because it felt just like Sweden. Early Happy Valley pioneers included the Olson, Johnson, Carlson, Elduen, Bloomskog, Herberg, and Isackson families.

Logging in the Redmond area flourished in the early 1900s. During 1913, timber workers at Redmond organized a union. In 1914, Albert Johnson headed the union, which had 75 members.

Transportation improved as the automobile became more common. The first brick highway, west of the Rockies in Kent, Washington, was opened Christmas 1912. Construction of Redmond's Red Brick Road began in 1913.

During the Great Depression when you couldn't buy a job in Redmond, several men left Redmond for jobs in Nevada including Fred Reil, Willis Ottini, and Ernie Adams.

Redmond incorporated as a City in 1912 and the population grew slowly from 303 in 1912, to 573 in 1950, and 1,426 in 1963. In 1963, the Evergreen Floating Bridge was completed and by 1970 the population had multiplied to 11,020.

Brad Best's Land Bulletin of Spring, 1965, included listings such as 40 acres a mile from Redmond near the Evergreen Point Floating Bridge available for $1,975 per acre, 20 percent down and easy payments.

One

SOME FAMILY HISTORIES

The 1880 Census for what became Redmond listed 50 people including Indians by first names: Jim, Alice, John, Phoebe, Sam, Laura, Sue, Bill, Mollie, Julia, Jack, Mollie, Annie, and Joe; bachelors Frank George, Conrad Hartman, and John Stevens; Adam and Elizabeth Tosh, children Sarah Ann, Robert, John, Margaret, and Agnes; Adam's brother John Tosh, his wife Elizabeth, children Joseph, Sarah, and Jennie; Warren and Laura Perrigo; William P. and Matilda Perrigo and their children Robert and Marve; James and Charlotte Perry, their children Clara, John, Thomas, and David; Luke and Kate McRedmond and children John, Richard, Emma, David, and Anna McRedmond. William McRedmond, 20, was mining in the coal-rich area of Newcastle, south of Bellevue at the time.

Katherine Forgue Barker, an elder with the Snoqualmie Tribe who is responsible for enrollment and archives, explained that Native-American grandparents generally told stories to their grandchildren and that their histories were not always written down. Sometimes members carried walking sticks and each year they would all add a notch. This was one way to keep track of ages. Katherine's ancestor, Mary Louie, lived to about 124. Mary's brother, Jim Graham, lived to 117. Katherine Barker's Indian name is Qwhaltsa. Katherine and five of her older brothers and sisters were delivered by Redmond's beloved Dr. Davis.

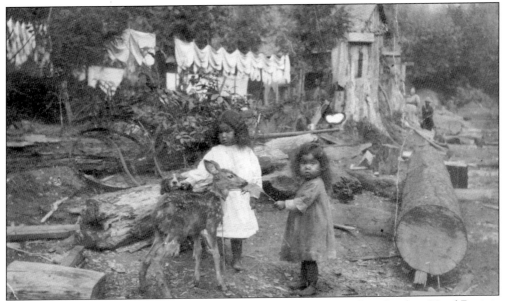

Ed Davis and his wife are pictured near the entrance of their home. Their daughter Hazel Davis is petting the deer while her sister Elizabeth watches. They were members of the Snoqualmie Tribe and were early loggers on Lake Sammamish. Ed died a few years ago at the age of about 100.

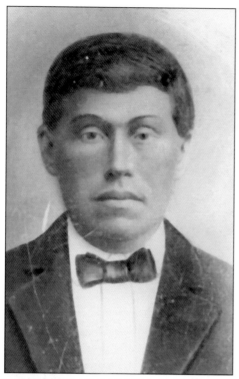

Jim Graham, left, attended the signing of the 1855 Point Elliot Treaty with Isaac I. Stevens, governor and superintendent for Indian Affairs for Washington Territory. Jim's Indian name was Quahla.

Jim's sister, Mary Louie was born near the confluence of the Tolt and Snoqualmie Rivers, near modern-day Carnation, sometime shortly after 1800. As a member of the Snoqualmie Tribe, she was part of an extensive network of villages up and down the Snoqualmie River valleys.

In the 1850s, the Snoqualmies and white settlers battled for fertile farm land. Mary Louie's husband and son were killed. She fled to the Cedar River, which was a gathering place for many tribes. There she met and married a Duwamish man known as Charlie Louie. Charlie died at an early age from tuberculosis, but Mary and their son Johnny continued to live at the lake. His mother was known as "Aunt Mary" to the many white people who bought her handmade rugs or used her native remedies for illness.

Mary's son, Johnnie Louie (1869–1925), was the father of Dwenar Ellen Louie. Johnny often worked in the Issaquah-area hop field.

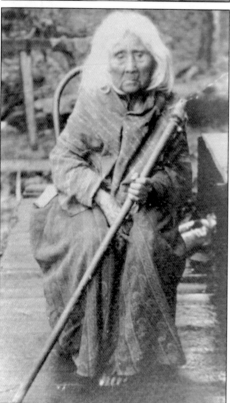

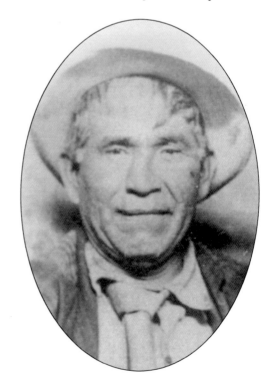

Pictured are, left to right, Dwenar Ellen Louie, Dutch Lozier, and Mable Bagley (wife of Bill Bagley). This picture was taken when Johnny Louie took Dwenar into Seattle to get her first store-bought dress and have her photograph taken. Johnny then took her photo and traveled across the state to find her a suitable husband.

Dwenar married Joseph Forgue, shown here with his sister Elizabeth and father, Casiner Forgue. This Forgue family was living on the Yakima Reservation. Once married, Joseph and Dwenar split their time between the two sides of the mountains.

Eli George, Dwenar's cousin (*below, right*) and Tom Henry enjoyed dressing up as cowboys in 1913.

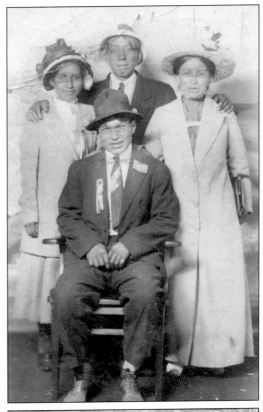

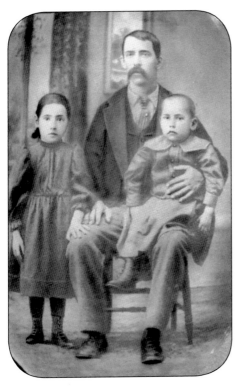

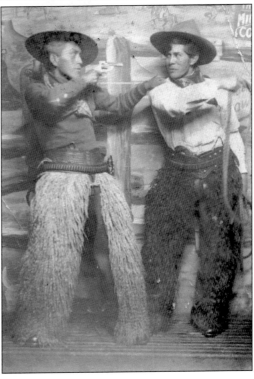

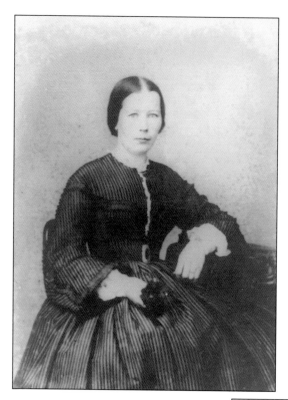

Kate Barry was born in the Lakes of Killarney, County Kerry, Ireland about 1833. Her brother and sister were living in Boston when her parents, George and Harriet Barry died in Ireland. Kate was a child traveling alone on the Black Ball Line from Liverpool to New York when she met Capt. Richard B. Morse. He was the first mate responsible for delivering her to her brother and sister in Boston. He continued to keep in touch with her and later they were married on May 17, 1856 in Charlestown, MA. She was pregnant when they sailed to near the Panama Canal, then walked overland to take a boat to Santa Cruz, California where she gave birth to James Morse. They moved to Port Townsend.

Luke McRedmond was a good friend of James Morse. When James was dying in 1859 in Port Madison, he suggested that she marry Luke.

Luke McRedmond was born about 1818 in Knockhill, County Kings, Ireland. After coming to America, he first lived near his brothers Richard and Edward McRedmond in Troy, New York. In 1849, at the time of the discovery of gold in California, Luke was living in Memphis, Tennessee, working at the government Navy yard near that city.

In 1850, he journeyed around Cape Horn to California where he settled. In 1851, he again set sail for the Puget Sound and settled in Port Madison, Kitsap County. At that time Kitsap County was one of the fastest growing and most profitable areas in the nation. Luke was a ship captain transporting logs to San Francisco. Luke McRedmond managed Meigs lumber mills in Kitsap County.

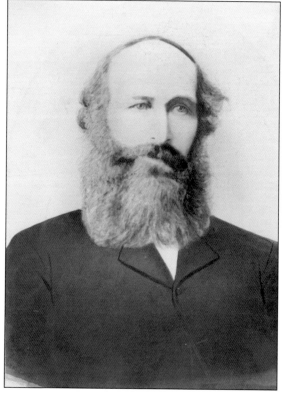

Anna McRedmond, pictured on the left, was born on November 26, 1872. She was the first non-Indian child born in the area later to be named Redmond. Luke went to Woodinville by canoe to get Ira Woodin to help with the delivery of Anna. Then the trip to Woodinville was so long and arduous a Native-American woman delivered the baby before he returned. Anna later recalled: "Father was always a friendly man with the Indians, and when one of them died, they came in great groups and sat in our yard and mourned. When I was a child, the Indians came to our place all the time. They would sit around and watch us until my mother gave them something to eat. I was never afraid of them." Emma Francis McRedmond is pictured on the right. Emma was born in 1869 while her family lived in a large home on First and Madison overlooking Elliot Bay in Seattle. Emma's middle name is for Father Francis Xavier Prefontaine, who established Seattle's first Catholic Church, Our Lady of Good Help in 1869.

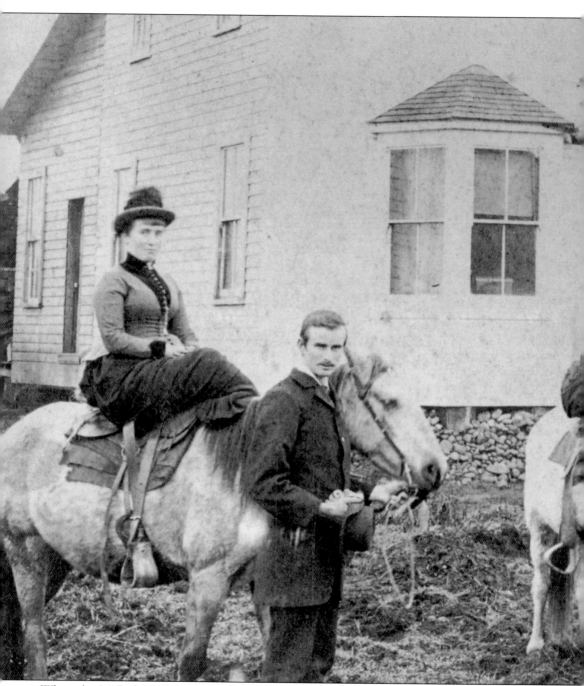

When the McRedmond family first moved to Redmond, Kate sent her son James to get the mail for the area. He would row a boat down the Slough, stay his first night at the Woodin family home, go on to Bothell, and across Lake Washington to Leschi. He next rode a horse to 2nd and Cherry, where the ships were in from California and the East Coast. He then went on horse back to North Bend, down to Novelty, between Tolt and Duall, and crossed the river at the John Ames place. His trip took him one whole week.

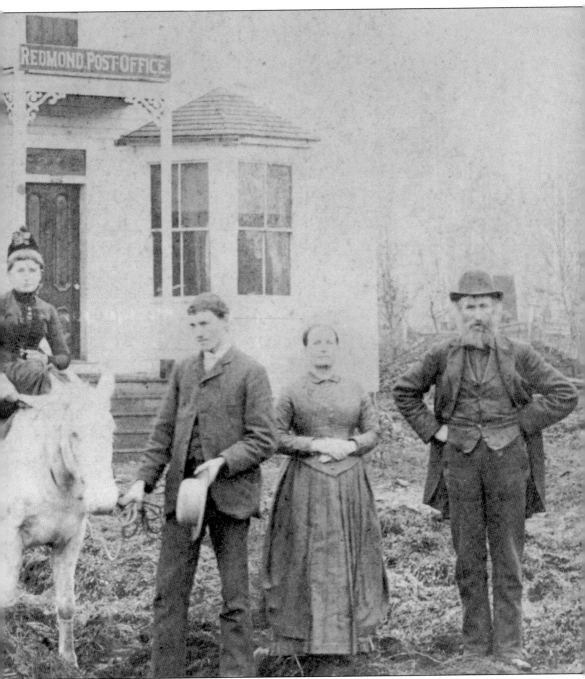

This photograph was captioned by Ruth White Eacrett: "About 1886. First Post Office run by Emma McRedmond. Pictured left to right are Emma, William, Anna, Richard, Kate, and Luke McRedmond. Luke was appointed postmaster in 1882. His petition to change the name of the post office to Redmond was granted on March 19, 1883. William McRedmond became postmaster on July 2, 1883. Emma became postmistress in 1885.

This photograph appeared in the *Sammimish Valley News*, captioned as an early homestead in Redmond. Notice the width of the huge tree that was cut. The boy in this picture might be David McRedmond, who was born in Seattle in 1871. Luke and Kate's three older sons were: William, born about 1860; John Luke McRedmond, born about 1863; and Richard B. McRedmond, born about 1867.

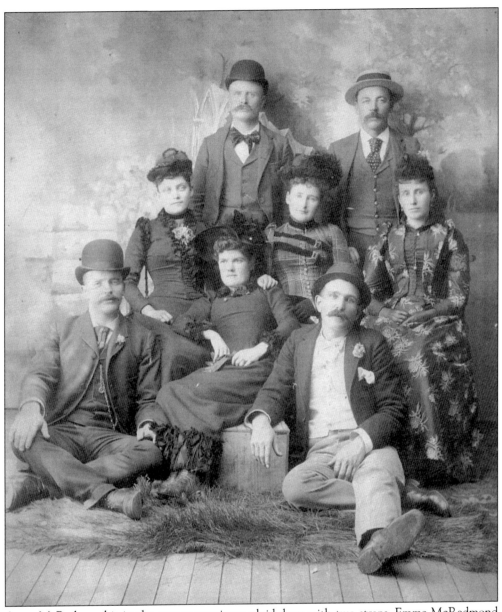

Anna McRedmond is in the center wearing a plaid dress with two straps. Emma McRedmond is to her left in the print dress.

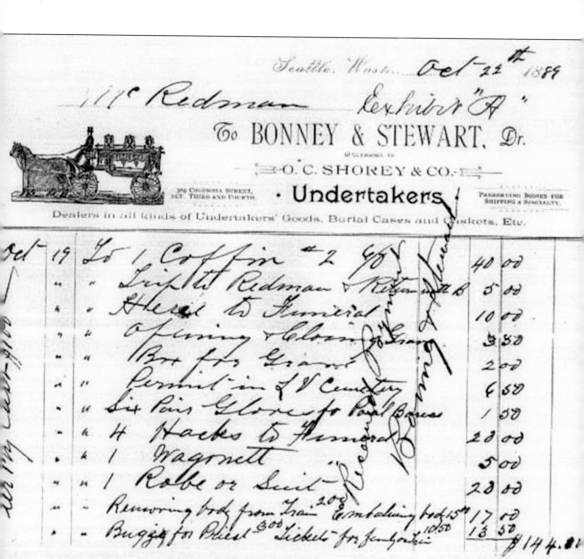

Seattle, Wash. Oct 22nd 1889

Mr. Redman — Exhibit "A"

To BONNEY & STEWART, Dr.
SUCCESSORS TO
O. C. SHOREY & CO.
309 COLUMBIA STREET,
BET. THIRD AND FOURTH.
· Undertakers ·
PRESERVING BODIES FOR
SHIPPING A SPECIALTY.

Dealers in all kinds of Undertakers' Goods, Burial Cases and Caskets, Etc.

Oct	19	To	1 Coffin #2	40	00
"	"	"	Trip to Redman & Return	5	00
"	"	"	Hearse to Funeral	10	00
"	"	"	Opening & Closing for Grave	3	50
"	"	"	Box for Grave	2	00
"	"	"	Permit in L V Cemetery	6	50
"	"	"	Six Pairs Gloves for Pall Bearers	1	50
"	"	"	4 Hacks to Funeral	20	00
"	"	"	1 Wagonett	5	00
"	"	"	1 Robe or Suit	20	00
"	"	"	Removing body from Train 2.00 Embalming body 15.00	17	00
"	"	"	Buggy for Priest 3.00 Tickets for fan hacks 10.50	13	50
				$144	00

John Luke McRedmond was the first of Luke's sons to die on October 19, 1889. His brother William died a few months later. Florine Alexander, a descendent of Kate's son, James, said the boys had become ill after drinking milk from a sick cow.

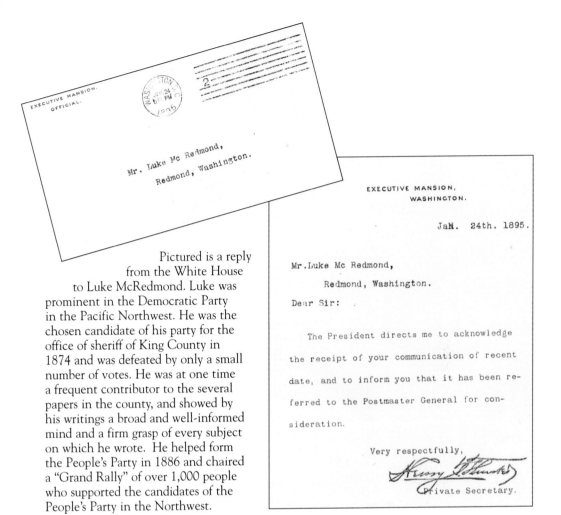

EXECUTIVE MANSION,
WASHINGTON.

JaN. 24th. 1895.

Mr.Luke Mc Redmond,

Redmond, Washington.

Dear Sir:

The President directs me to acknowledge
the receipt of your communication of recent
date, and to inform you that it has been re-
ferred to the Postmaster General for con-
sideration.

Very respectfully,

Private Secretary.

Pictured is a reply from the White House to Luke McRedmond. Luke was prominent in the Democratic Party in the Pacific Northwest. He was the chosen candidate of his party for the office of sheriff of King County in 1874 and was defeated by only a small number of votes. He was at one time a frequent contributor to the several papers in the county, and showed by his writings a broad and well-informed mind and a firm grasp of every subject on which he wrote. He helped form the People's Party in 1886 and chaired a "Grand Rally" of over 1,000 people who supported the candidates of the People's Party in the Northwest.

Pictured is a later McRedmond family home.

Anna McRedmond married Elmer Smith, a conductor for the Seattle, Lakeshore & Eastern Railroad, on December 11, 1893. Elmer was the son of Cornelius W. Smith, a Civil War veteran who served with a Minnesota regiment. Hazel Smith was born on September 19, 1894 in Helena, Montana.

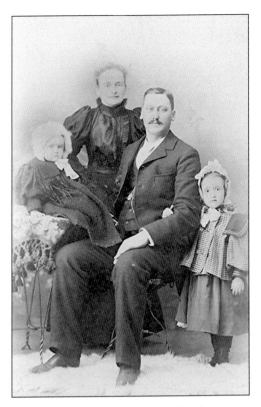

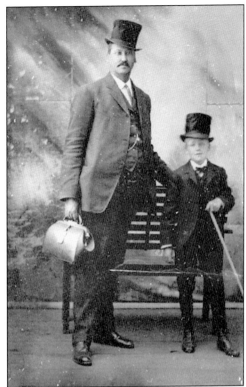

Pictured above are Percy Luke Smith, Anna McRedmond Smith, Elmer Smith, and Hazel Smith in Great Falls, Montana. When Kate McRedmond died on October 5, 1895, the Smiths were still living in Montana. We are uncertain when the Smiths moved back to the Seattle/Redmond area permanently, but believe it was before 1900. Elmer continued to work for the railroad and also operated a ranch in Redmond on his property and the White's. He was also in the hay and feed business, and Ted Youngerman, who lived at the Hotel Redmond, was his partner for some of this time. Elmer suffered injuries due to a train accident, which he died from in 1928. Anna's letters mention her appreciation of many railway workers who were frequent visitors while Elmer was struggling to recover. His funeral was conducted by Elks's and Order of Railway Conductors.

(*left*) Hazel and Percy Luke Smith were photographed by Fullerton in Great Falls, Montana. Many people today remark on the dour expressions found in 19th century photographs. One would think that not a single person in the 1800s ever smiled. However, these expressions were a result of the process, not the personality of the subject. The exposure time for the early photographs was several seconds. Any movement while the photograph was being taken would blur the image. Evidence of this can be seen in photographs of people and their pets, like dogs. The dog is usually blurred, while the people are clear and in focus. Because of this factor in 19th century photography, portrait sitters were asked not to smile. Thus the sitter was instructed to maintain a normal facial expression, which could be done without movement, while the plate was exposed.

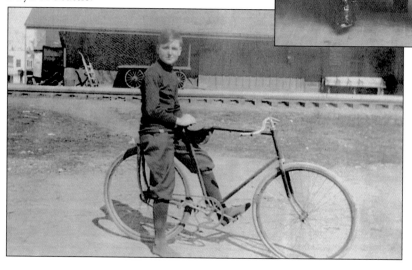

(*right*) William E. Smith was born on January 12, 1902 and his sister Helen Smith was born on April 17, 1900. The photographer was Boyd of Seattle.

(*left*) William E. Smith, seen here on a bicycle in front of the train station, is facing the Hotel Redmond.

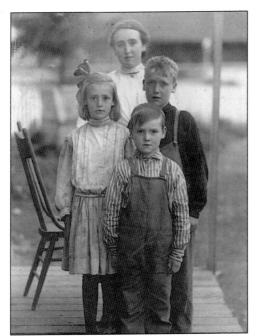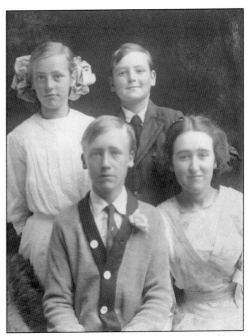

Pictured are the Smith children a few years later: Percy and Hazel in front, Helen and William in back. Helen married Eugene Aloysius Eugene O'Flaherty, a military officer and instructor at West Point. William became a banker.

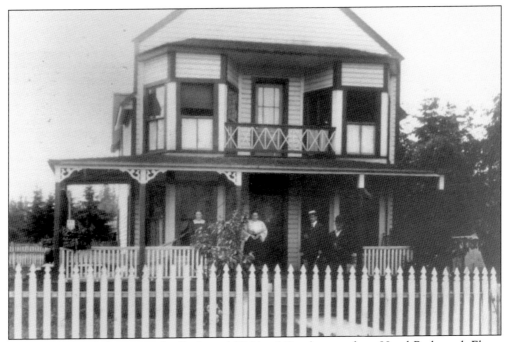

This is the Smith home on the Redmond Kirkland Road across from Hotel Redmond. Elmer formed a partnership with Ted Youngerman for a dry goods store and continued to work for the railroad until an accident in the late 1920s. The Smiths also had a home in Seattle, as the Eastside schools did not go higher than the 8th grade until 1909.

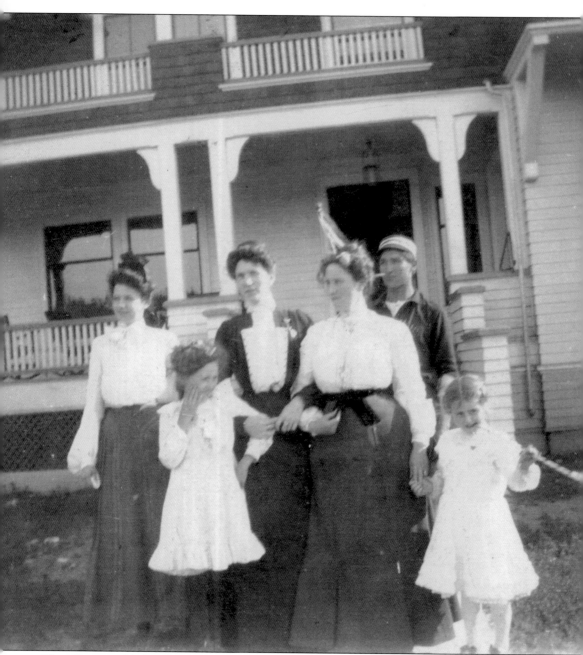

This photo was likely taken on the same day as the cover photo. The children are Hazel Smith on the right and Helen Smith on the left of Anna McRedmond Smith. It is possible the man in this photo is Anna's brother, David McRedmond. David is pictured in the log schoolhouse photo on page 115. David Barry McRedmond managed the Hotel Redmond for Emma and Judge White when they were in Seattle. He died on January 28, 1905, at the age of 34, of consumption. He was the last of Luke McRedmond's sons to die.

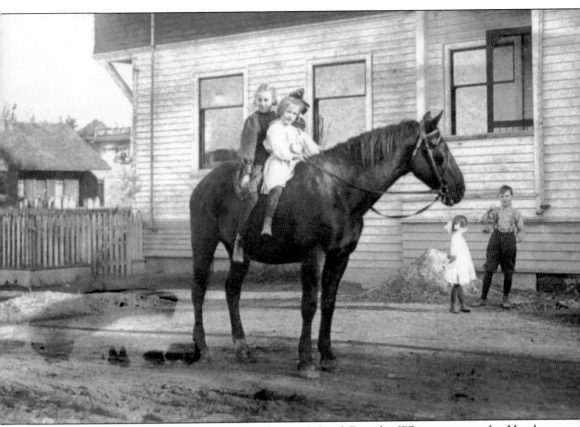

Pictured on the horse is Helen Smith, who sits behind Dorothy White, next to the Hotel Redmond. The other children are probably William E. Smith and Ruth White. The train station is in the background. They are on the Redmond-Kirkland Road, facing the Smith home.

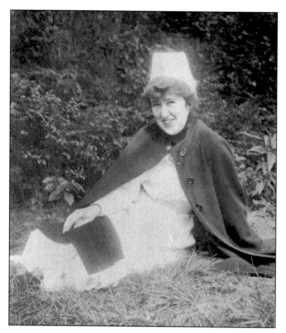

During the first call for WWI nurses, Hazel Smith was employed as a school nurse at the Aquinas Academy in Tacoma where her younger sister Helen was a student. Hazel entered the service the day after Percy, and took up her duties as a nurse in the temporary cantonment at Camp Dodge, Iowa, before continuing to France. She served nearly a year in France with the University of Washington hospital unit. Hazel married Edward M. Grogan, a government attorney who worked for the Department of the Army. Hazel died while giving birth to their second daughter in 1933. Anna McRedmond Smith moved to Portland to help take care of Hazel's children. Helen Smith married Aloysius Eugene O'Flaherty Jr., a West Point graduate stationed at Ft. Lawton in 1924. His career took them to the Phillipines, West Point, and Ft. Benning in Georgia before Helen took the children to Portland while Colonel O'Flaherty led a WWII infantry regiment under General Patton. Percy joined the family in Portland working as a welder, building Kaiser ships for the war. William became a banker in Portland. The Smith families lived near each other in Portland. In 1954, Anna, Percy, and Helen's husband died. Ed Grogan, an air raid warden during WWII, lived to be 94.

This is Anna McRedmond Smith's 1932 Christmas card. Pictured are Helen Katheryn Grogan, Rita Joanne Smith, Aloysius Eugene O'Flaherty III, and Anna McRedmond Smith. The back of the card reads, "Florence (Quail) dear. Hope you have a very wonderful Christmas. Our little Helen was in the hospital as Dennis O'Flaherty arrived Sunday night 9:45. Thinks he's half grown already—weighs 9 lbs. And is Paddy's double. Please let Dorothy know. Helen feels pretty good all things considered." Dennis O'Flaherty grew up to marry Joan Hannah Dempsey, daughter of world-renowned heavyweight champion, Jack Dempsey.

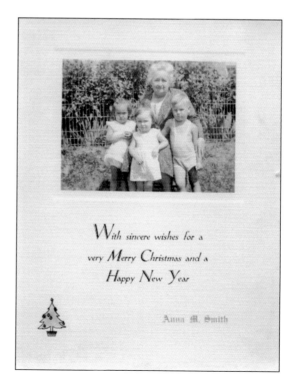

With sincere wishes for a
very Merry Christmas and a
Happy New Year

Anna M. Smith

Judge William Henry White arrived in Washington Territory in July of 1871 and became a Probate Judge in Seattle that year. The population of Seattle numbered 1,200 at the time. He entered into a law partnership with Colonel Larabee that continued until 1873. In 1876–78, White was elected prosecuting attorney of the third Judicial District of Washington Territory, comprising of all of what is now western Washington. In 1878 he was Seattle City Attorney for one term. He was then elected from King County to the Territorial Legislature from 1878–80, and became chairman of the Judiciary Committee. One newspaper article states: "The term 'War Horse Bill' resulted from his activity in the campaign of 1884 to represent Washington Territory to Congress. He started out on a white horse with a pair of old-fashioned saddle bags filled with campaign literature. Before the end of the campaign he visited and spoke in nearly every precinct in King County and was given the credit for the election in that campaign of Judge J.T. Ronald as prosecuting attorney and Charles F. Munday as the "kid" member of the legislature. Later they formed White & Munday, one of the oldest law firms in the Territory.

Grover Cleveland

PRESIDENT OF THE UNITED STATES OF AMERICA,

To all who shall see these Presents, Greeting:

Know Ye, That by virtue of the authority conferred upon the PRESIDENT by section 1768 of the Revised Statutes of the United States, I do hereby SUSPEND John B Allen of Walla Walla Washington Territory from the office of Attorney of the United States for the Territory of Washington until the end of the next session of the Senate, and I hereby DESIGNATE William H. White, of Seattle, Washington Territory to perform the duties of such suspended office in the meantime, he being a suitable person therefor; subject to all provisions of law applicable thereto.

In testimony whereof I have caused these Letters to be made PATENT, and the Seal of the United States to be hereunto affixed.

Given under my hand, at the CITY OF WASHINGTON, the thirteenth day of July, in the year of our Lord one thousand eight hundred and eighty five, and of the Independence of the United States of America the One hundred and tenth.

Grover Cleveland

By the President:

T. F. Bayard
Secretary of State

White was U.S. Attorney for Washington Territory when Chinese railway workers were killed in Issaquah. On February 7, 1886 when mobs in Seattle tried to force the Chinese, many of whom had come to build the railroads, onto ships and out of town, William H. White was immediately called. He ran to the docks and ordered the police to break up the mob. They refused. He ordered the crowd to disperse, and they refused. He then ran to Engine House Number One to sound the alarm and issued the call-to-arms to the Home Guard, despite efforts by the mob to stop him. Judge White obtained indictments against all accused. President Grover Cleveland appointed William H. White U.S. Attorney for Washington Territory, an office he held from 1885 until statehood.

Walter Sheppard Fulton retired as King County prosecutor in 1903 to become a criminal attorney. Ralph Bushnell Potts in *Come Now Ye Lawyers* writes, "Old Timers who remember Walter Fulton, claim that he was the most eloquent orator and the best jury lawyer the State of Washington had ever seen. He was very imaginative and very sentimental about his aging mother. Fulton represented a man charged with murder. While Fulton pondered the defense he watched the motherly appearing cleaning lady. He asked if she would sit in court to sit beside this young defendant, and whenever the prosecuting attorney began 'roasting' the young fellow, she was to slyly pat him on the back. When he made his closing argument in that very rich voice of his (which spectators claimed was almost like music) he almost sang the words of a new poem by Rudyard Kipling which his mother had given him: 'Mother of Mine—If I were hanged on the highest hill, I know whose prayers would follow me still, mother of mine.' That was in the main Fulton's argument. The jury brought in the verdict of 'not guilty.' A juror's response to a cynical newspaper reporter was 'Well, I'll tell you, son, if I hadn't voted the way I did, I couldn't have come back into that jury box and looked that nice mother in the eye, or any other mother, I guess.'"

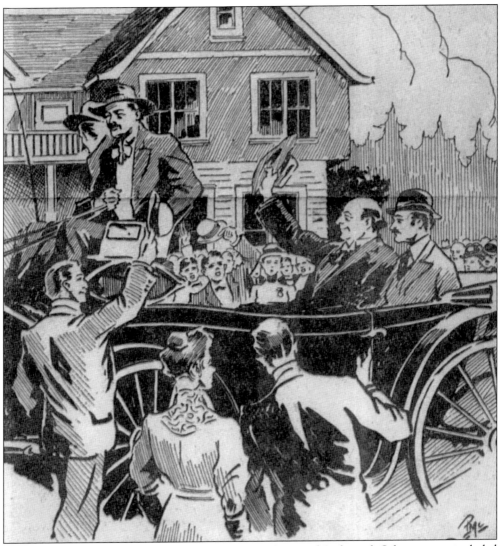

This sketch shows William Jennings Bryan visiting the Hotel Redmond. Other visitors included U.S. President Howard Taft, Percy Rockefeller, Sam Hill, and Teddy Roosevelt. White was chairman of the 1896 Washington delegation for the Democrats in Chicago which nominated William Jennings Bryan for his first presidential nomination. Judge White supported Bryan in his first two campaigns, but later broke with the Democrats because he disagreed with the Democratic policy on the issue of the Philippines. Judge White was named national committeeman for Washington by the Ellensburg Convention. Judge White supported Governor Rogers in his elections. Governor Rogers appointed White to the Washington Supreme Court from June 1900 until January 14, 1901, to fill the unexpired term of Judge M. J. Gordon. White was reappointed again under an act temporarily increasing the number of members of the Washington Supreme Court. In *Palmer vs. Larabee*, White wrote that courts "cannot correct what they deem excesses in legislation" but if enactments threatened such fundamental provisions of the state constitution as the right of contract they become "obnoxious to all constitutional restriction, and should not be upheld." He and his colleagues then promptly invalidated the law. Judge White helped form the Republican Party of Virginia. He walked on crutches to cast his vote for Abraham Lincoln in Lincoln's second presidential election.

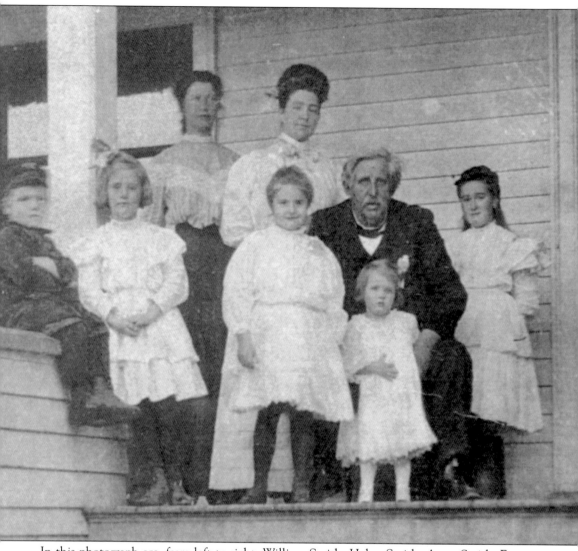

In this photograph are, from left to right, William Smith, Helen Smith, Anna Smith, Emma White, Martha White in front of her, Dorothy White in front of Justice White, Hazel Smith leaning against the wall.

(*opposite page*) Letters provide great insight into pioneer life. In the letter opposite, the Judge mentions his sister Martha, Aunt Lizzie, and Mrs. James Nugent, who's daughter Etta married Walter Sheppard Fulton. In 1881, Judge White's sister, Martha White Fulton, and her son, Walter Sheppard Fulton, then eight years old, came to reside with him. They first lived at the Butler Cottage, then helped on the 320 acre farm in Avondale. As soon as Madison Street was cut through as a wagon road to Lake Washington, Mrs. Fulton moved to the shores of the lake and built a house on what is known as Denny Place, just north of the Firlock Club where the Seattle Tennis Club is now located. Mrs. Fulton was a founder of the Seattle Day Nursery and an active worker in the Ladies' Relief Society. Martha White Fulton died in 1912.

June 25th 1901

Dear Wife & Baby

Your letter just received I got a letter from my sister in yesterday and she says Auntie is going to leave for Pittsburgh on Thursday. It appears that Mrs Nugent is going east and Auntie thought it would be better for her to go with her

If you go in on Wednesday telephone for Auntie Liz gie to come to the Butler and have lunch with you. I will try and be home Friday on the train but they count may hold a City session on Friday if so I cannot get away until Satur day on the boat at Kimbaly & tell her papa will soon be here

affec't W. H. W

33

The State Constitution was amended in 1910 to allow women to vote. Mrs. White was nominated by the Democratic Party without contest for the office of county clerk of King County. Excerpts from campaign articles included: "The women should vote for her because she promises that, wherever possible, deserving and competent women will be given suitable positions. Her husband is a Union veteran; and there can be no doubt that his comrades will receive sympathetic consideration and proper recognition from her."

Widely known as a Democrat, Judge White became a supporter for President Roosevelt for the later second term and with the organization of the Progressive Party he became an active member of the Moose Movement, being elected as a Republican and Moose Delegate to their 1912 convention. Mrs. White was a member of the 1912 Democratic Delegation from King County to the state convention the same year.

Justice White is seen here relaxing on the porch of the Hotel Redmond. On the day of his funeral, April 29, 1914, the *Seattle Post-Intelligencer* reported that the nine branches of the King County Superior Court had adjourned so all the judges could salute the man who more than most, brought law and justice to the wild Northwest. He was buried in Lake View Cemetery.

Judge William H. White and Emma McRedmond are pictured here about the time of their wedding in June 1898.

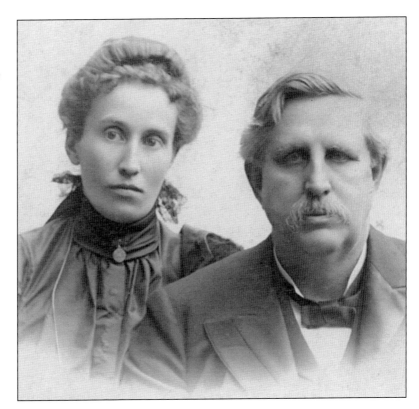

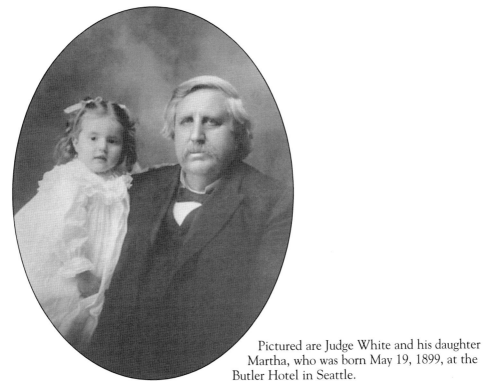

Pictured are Judge White and his daughter Martha, who was born May 19, 1899, at the Butler Hotel in Seattle.

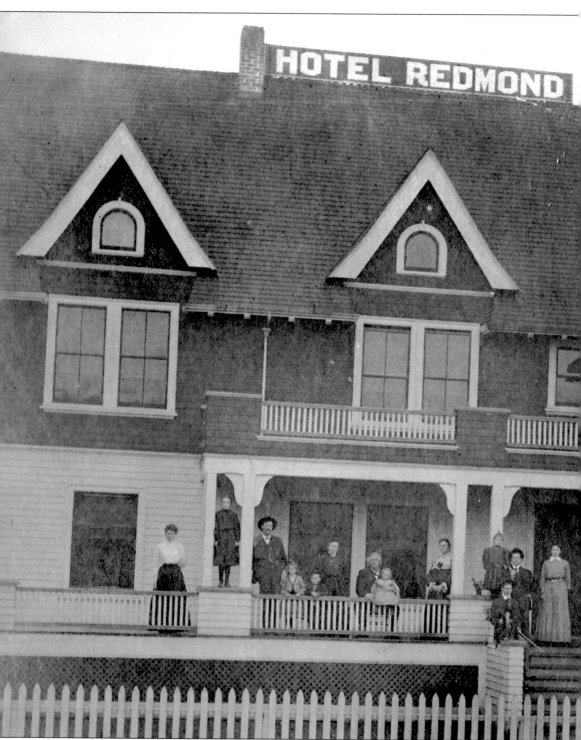

Pictured here in front of the Hotel Redmond in 1907, are, left to right: unidentified, Hazel Smith, Elmer Smith, Helen Smith, William Smith, Anna McRedmond Smith, Justice William H. White (holding daughter Dorothy), Emma McRedmond White (pregnant with daughter

Ruth), and Martha White leaning against post. Percy Luke Smith is probably sitting with the dog and gun on the left side of the steps. We would like to identify the others.

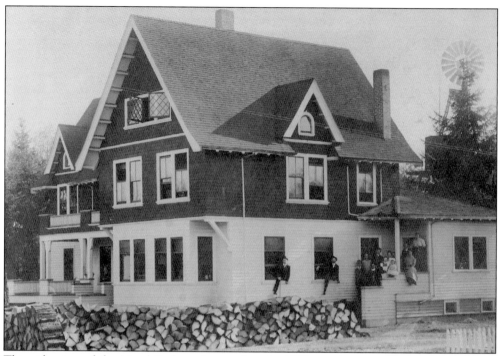

This side view of the Hotel Redmond was taken in 1907, on the same day as the photo on preceding page.

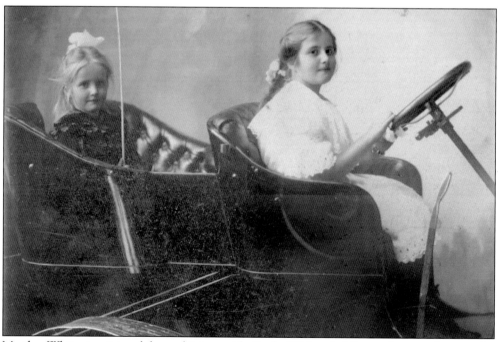

Martha White is pictured here driving with Ruth White, holding a buggy whip in the photographer's studio about 1910.

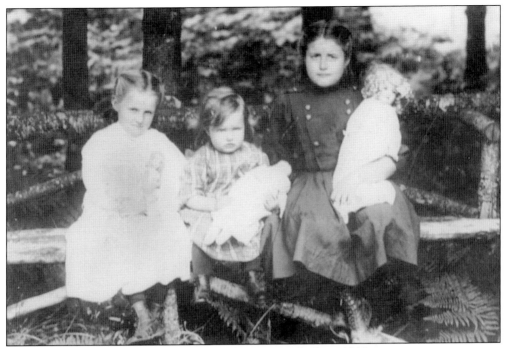

Pictured are Dorothy, Ruth, and Martha White in woods about 1910.

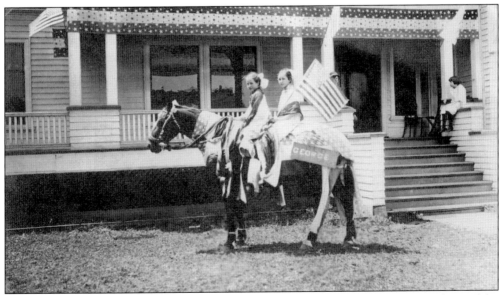

Martha and Dorothy White are pictured here on George, Justice White's horse, in front of the Hotel Redmond on the 4th of July.

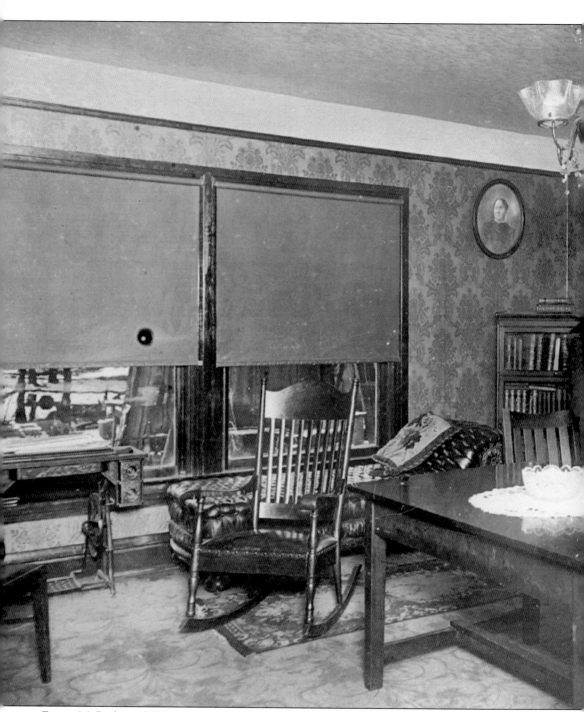

Emma McRedmond White is standing with Anna McRedmond Smith as she plays the piano in the parlor of the Hotel Redmond. Before the Hotel Redmond was built, Kate McRedmond would sing with her son James and daughter-in-law, Lydia Denyer Morse. Lydia's daughters Velma and Vera studied Music at the University of Washington. On the back of a postcard from Lydia to her daughter Velma, she wrote that they couldn't find *Old Kentucky Home* and asked Velma to bring it home.

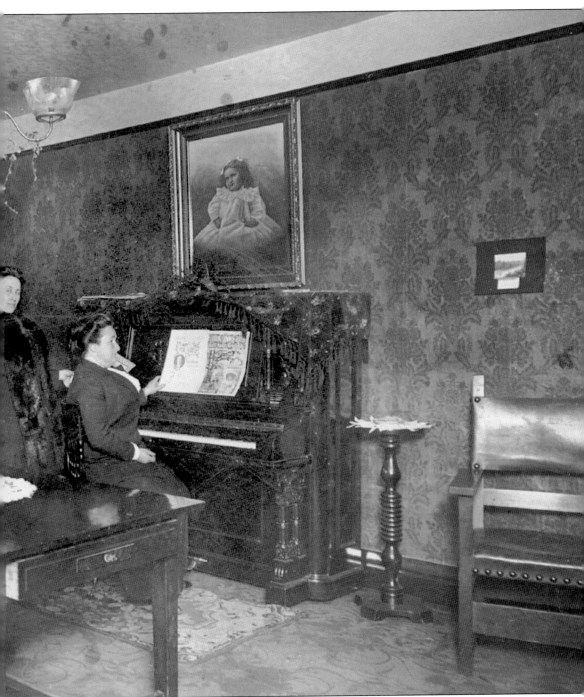

A portrait of Emma's daughter Martha is above the piano. Martha White was gifted with a beautiful singing voice and studied voice in San Francisco before she married Ray Gardner. As a member of the Ladies Musical Club, she was responsible for bringing famous vocalists such as Robert Merrill and Jan Peerce to Seattle for concerts. Martha was one of the founding members of the Seattle Opera and served on the Board of Directors of the Seattle Opera Association.

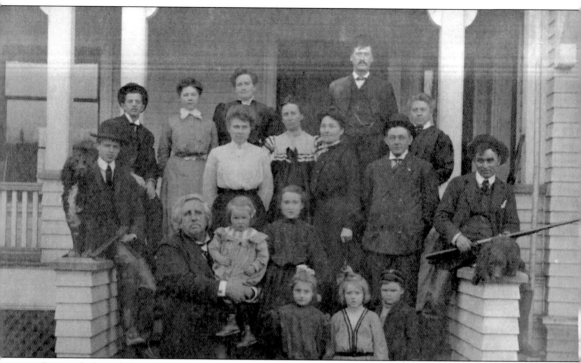

Pictured, from left, are: Justice White holding his daughter Dorothy; Martha White and Helen Smith, and William Smith with cap; Hazel Smith is behind Martha; Emma McRedmond White is immediately behind Hazel in a make shift maternity dress typical of the times; Anna McRedmond Smith is behind Emma on the left in the black dress; Elmer A. Smith is the tall man in the back row; and Percy Luke Smith is on the left side of the steps with the dog and gun.

Ruth White was born in 1907.

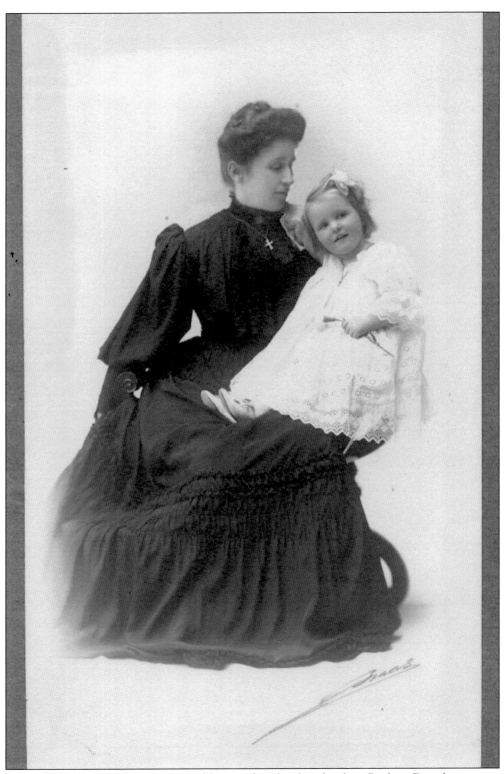

Emma McRedmond White is pictured here with either her daughter Ruth or Dorothy.

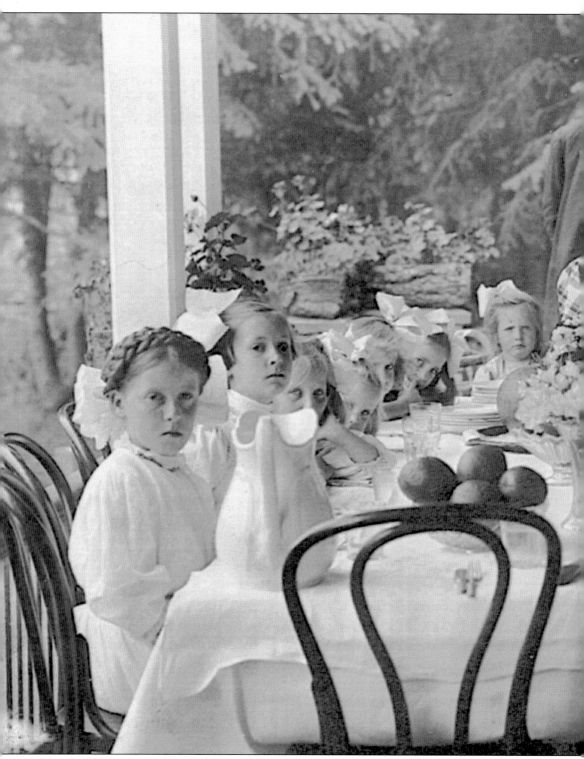

Dorothy White is seen here holding a doll and standing in front of her father at her seventh birthday party in July 1910. Her younger sister Ruth is to her right. Her sister Martha is the third

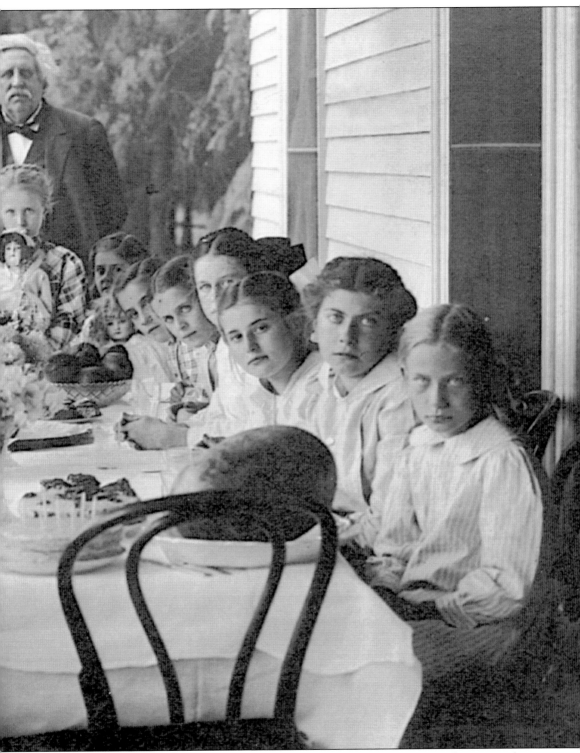

girl from the front on the right. You can see the candles on the cake next to the watermelon.

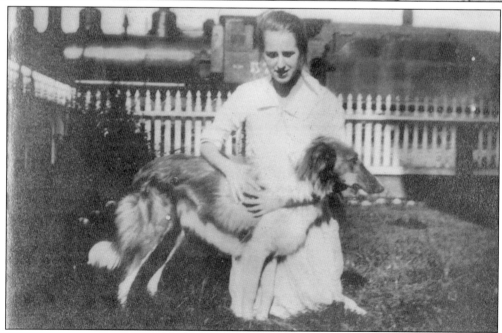

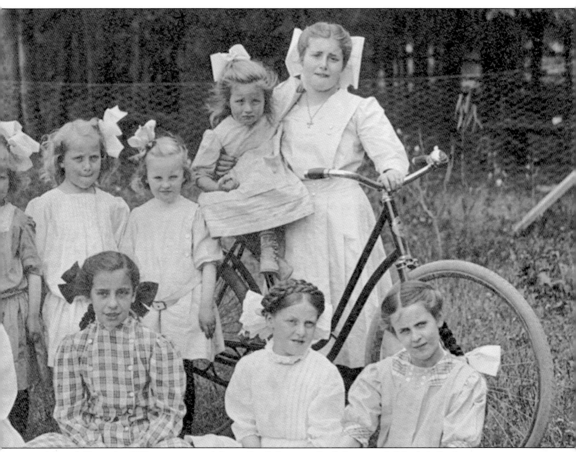

(*above*) Dorothy White is second from the left in a plaid dress with black baby buggy carriage. Martha White is standing on the far right holding Ruth White on a bicycle seat. These are the same 15 girls that attended Dorothy's seventh birthday party in July 1910. The two girls with similar hairstyles seated in the front row might be sisters as mothers often groomed their daughters in similar fashion. These girls pictured here and on the preceding pages are probably in the school photo on page 122, and possibly page 118.

Dorothy White is pictured to the left in the yard of the Hotel Redmond with a train passing behind her.

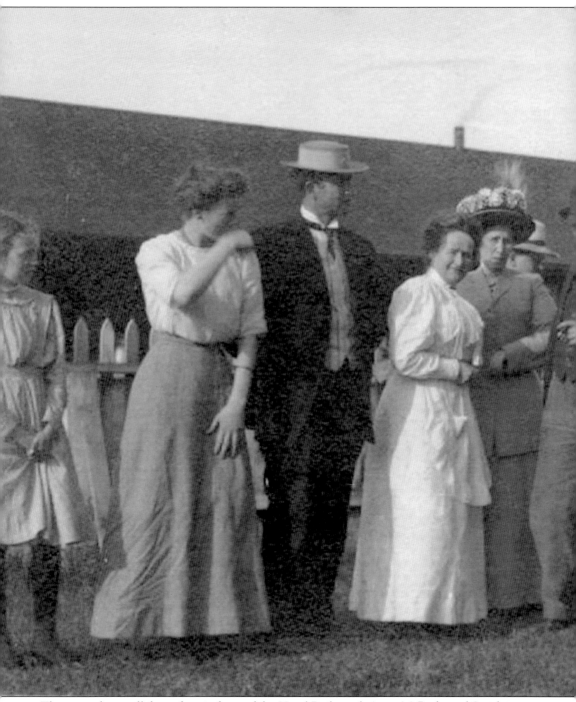

These people are all dressed up in front of the Hotel Redmond. Anna McRedmond Smith is in

the white dress, and Emma McRedmond White is to her left wearing the hat with flowers.

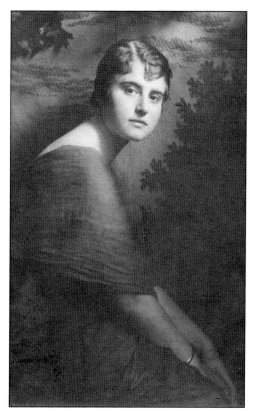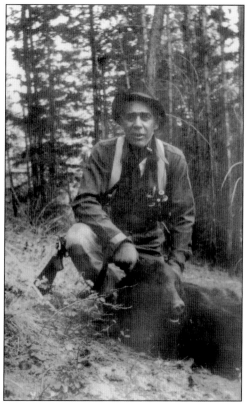

Martha White married Raymond Locke Gardner in 1922. She studied opera in San Francisco and was later appointed to the national council for the Metropolitan Opera. Martha donated a valuable collection of rare sheet music to her alma mater, the University of Washington. Raymond Locke Gardner, seen above trapping a bear, was an avid outdoorsman. He was born in Mosinee, Wisconsin in 1895, the son of Charles and Effie Pauline Locke Gardner. Raymond became a UW football star under legendary coach Gil Dobie from 1915–17. He served as a first lieutenant in the 44th Infantry Regiment and 13th Machine Gun Battalion. In 1919, he graduated from UW and became active in the lumber industry, beginning with Bryant Lumber Company where he was president. He began with Seaboard Lumber Company, manufacturers of fir lumber in 1935, becoming president. He was director of the West Coast Lumberman's Association and the National Lumberman's Association, and a member of Phi Delta Theta's General Council, serving as treasurer in the 1950s. Raymond died in 1961. In 1963, Martha married Emil Sick, owner of the Rainier Brewery, who bought the Seattle Indians late in 1937 and renamed them the Rainiers.

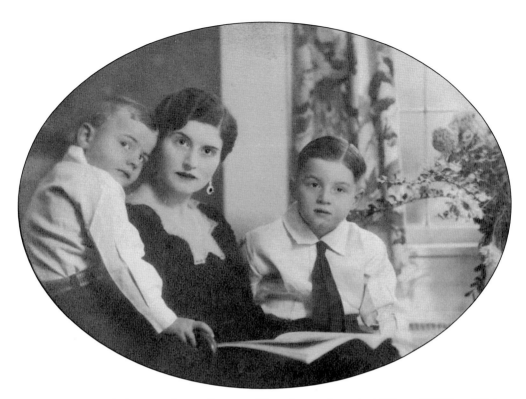

Martha is pictured above reading to Raymond Jr., who was born in 1922, and William White Gardner, born in 1924. Raymond Locke Gardner Jr. played football for UW under coaches James Phelan and Pest Welsh. During WWII he served in the famous Timber Wolf Division in Northern Europe. He was engaged in exporting and marketing large Northwest Wood Products, for use in building ships and homes. When WWII broke out, William White Gardner took a leave from Lake Side School for Boys to serve with the Edison Raiders and the First Divisional Brigade, which formed the nucleus of the Sixth Marine Division. He was wounded several times. Upon return, he graduated from Lake Side School for Boys, attended UW, and worked with his father at Seaboard Lumber Company. Barry Gardner had five sales centers for manufactured homes.

Diana Gardner is holding her brother Barry Gardner's hand. His first name is for his ancestor Kate Barry McRemond's maiden name. Diana married Panfilo Morelli (see page 83). They named a son McRedmond Morelli.

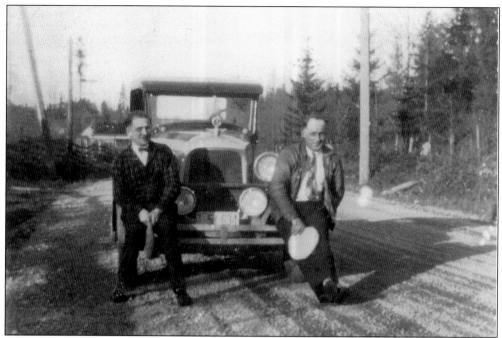

Lloyd Eacrett, at right, and friend came to Redmond in February 1927 to work on the Old Brick Road. He married Ruth White. Originally built in 1913, the road was part of the Transcontinental Yellowstone Trail connection Boston and Seattle and is now the longest remaining stretch of brick highway in King County.

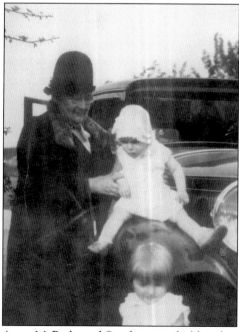

Anna McRedmond Smith is seen holding her granddaughter Mary Hazel Grogan. Patricia Eacrett Turple is in front of the car.

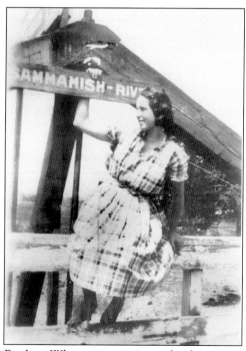

Ruth White is pictured here at Lake Sammamish.

George H. and Amelia Turple came to Redmond in 1902. Their original home and barns are among the oldest buildings in Redmond. G.H., Amelia, three of their daughters, and William H. White were among the charter members of the Happy Valley Grange. Since its organization, the Happy Valley Grange has been a vital factor in the economic, social, educational, and political life of the farmers of Redmond and vicinity. G.H. Turple donated a portion of his 20 acres to the Happy Valley Grange Hall in the early 1900s. His grandson, Ellsworth G. Turple, married Patricia Eacrett. They live on the original homestead.

Charter members of Happy Valley Grange No. 322.

Pictured in front of their home is the Ole Peter Sundholm family of Happy Valley.

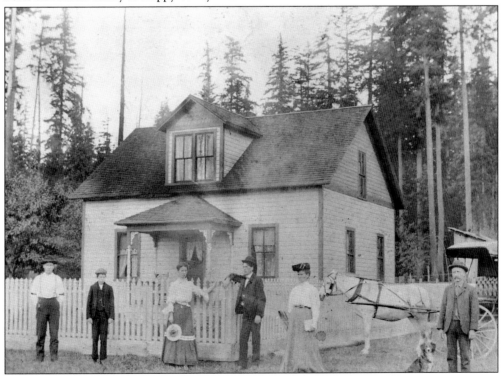

53

Robert Alexander Tosh is shown plowing the field above the Tosh Barn. He was Art Tosh's father and Colleen Tosh Willis's grandfather.

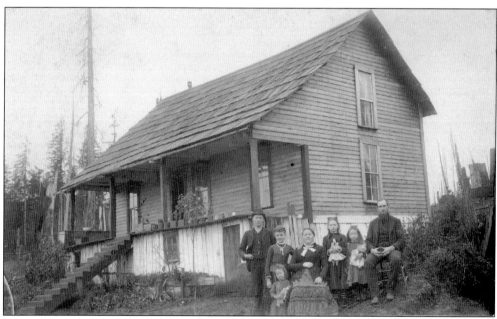

Pictured is the Adam and Elizabeth Morrison Tosh family, c. 1887. From left to right, the family members are Robert, Margaret, Elizabeth, Agnes, Julia, and Adam Tosh. Edith Tosh, born in 1885, is the baby in the front row. Adam and his brother John rowed to Issaquah coal mines to work. They used the money to hire Indians to come and slash brush on his place. Their homesteads are now Marymoor Park.

Adam Tosh, pictured here with his wife Elizabeth, became the first postmaster in what is now Redmond in 1881; he was appointed by the president. The post office was named Melrose.

Dr. George A. Davis was the first physician to settle in Redmond. He interned at Seattle General before moving to Redmond in 1915. He enjoyed touring the countryside with his medical bag, fishing gear, and Irish Setter, visiting the ailing as he went. When he was drafted in World War I, the people of Redmond petitioned his commanding officer at Ft. Lewis for his early return to Redmond. He married Julia Tosh, daughter of Adam and Elizabeth pictured above. They had three children: Betty in 1918, Phyllis in 1920, and Keith in 1924. When Betty and Phyllis later became doctors they realized how unusual their father's practice of rarely sending out bills was. Flagpole Plaza was dedicated to his memory after he died in 1945. Julia Tosh Davis died in the fall of 1972 at age 89.

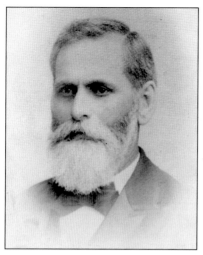
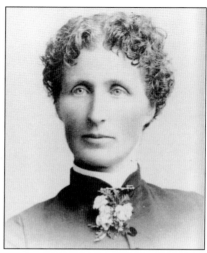

Warren Wentworth Perrigo and his young bride, Laura Perrigo, were living near Boston when Asa Mercer came on one of his renowned voyages to bring proper young women to the Puget Sound to meet eligible bachelors here. They traveled around Cape Horn. Warren taught school in Kitsap County for a few years and also worked at Henry Yesler's sawmill before moving to Redmond. One morning when Edna and De Whitt Griswold went to wake Laura Perrigo, they found that the gentle invalid was dead. What a terrible situation for the two young people, practically children, to be left in! Laura's husband was not at home. While they were considering what to do, a roomer came into the lobby, a schoolteacher from Snoqualmie Valley, and told the young people how to prepare Mrs. Perrigo's body for burial. They must wrap her in a blanket, and put her on a horse and walk to Houghton with her. It was approximately seven or eight miles. Here they could get help and someone there would help them ship the body on the boat to Seattle where she could be taken to an undertaker. What a heartbreaking trip!

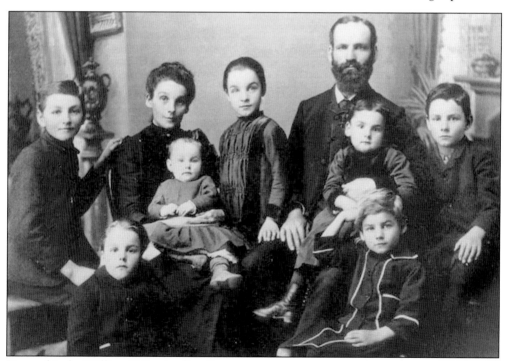

Pictured is the William P. Perrigo Family.

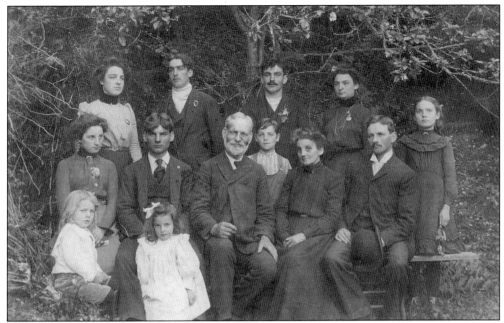

George F. Perrigo took this photo of the William and Matilda Perrigo family about June 1, 1903, just south of the old cabin on the hill. Pictured left to right are: (upper row) Mabel Perrigo Johnson, Arlington Perrigo, Marve Perrigo, and Nellie Perrigo Morris; (center row) June Perrigo Erickson, Wells Perrigo, William Perrigo, Thomas P. Perrigo, Matilda Perrigo, Robert William Perrigo, and Marian Perrigo Ulmer; (lower left) twins William Perrigo and Maude Perrigo Nelson.

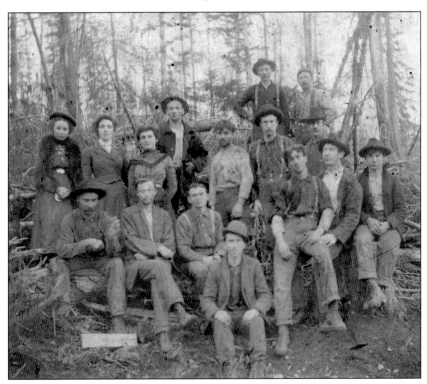

Pictured is the Robert Perrigo logging crew in Redmond in 1895.

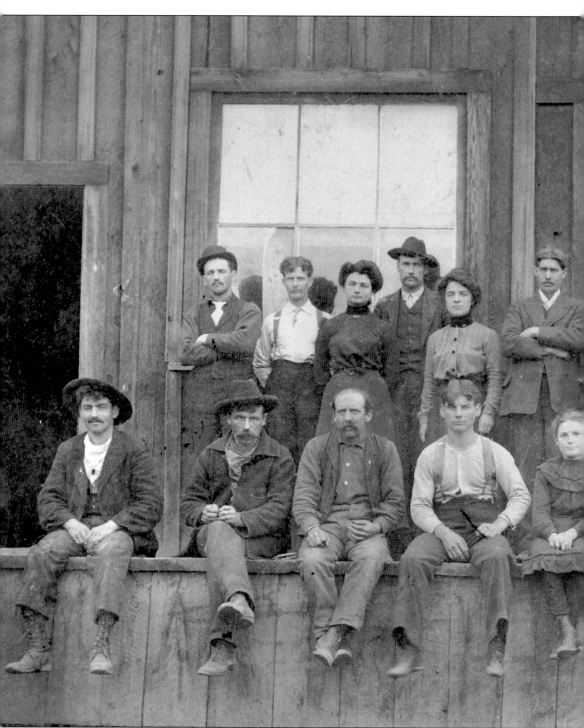

Pictured from left to right are: (front row) Marve, two loggers, Wells, Marion, Maud, and William Jr.; (back row) Robert, unidentified, Nellie, unidentified, Mabel, two unidentified, William P. (wearing a hat), unidentified, Matilda in the window with her brother-in-law, nad Walter Moore. William P. Perrigo opened his first trading post in Redmond in the

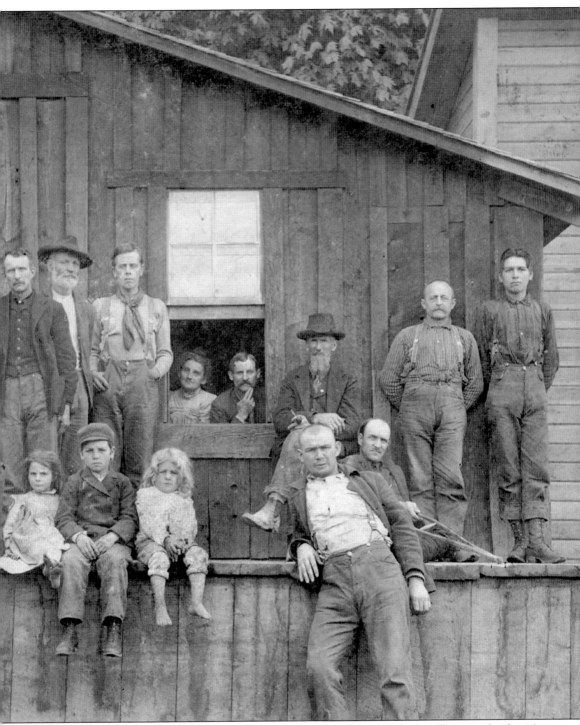

early 1890s. This picture, taken about 1902, shows a later post built of battened 1 by 12 feet boards. He sent goods on Indian ponies to other posts he established at farms between Redmond, Tolt, and Novelty. When coal mines opened at Gilman he also established posts at Cottage Lake and Paradise Lake.

The William P. and Matilda Thayer Perrigo family is, from left to right: (front row) Mable, Nellie, June, Marion, and Maude; (back row) Robert, Wells, William Jr., William Sr., Matilda, Tom, Marve, and Arlie.

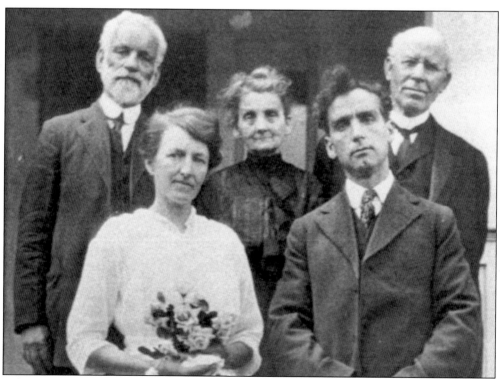

Arlington and Anna Perrigo are pictured in the front row on their wedding day. In the back row are the parents, William P. and Matilda Perrigo, and the preacher.

The William P. Perrigo home, built in 1909, is now the clubhouse for Eagle Rim Apartments off Avondale Road. The homestead is protected by a covenant created by Paul and Barbara Beeson that subsequent owners maintain the home and certain trees remain.

This is Matilda Thayer Perrigo, a few years before she passed away in 1932.

61

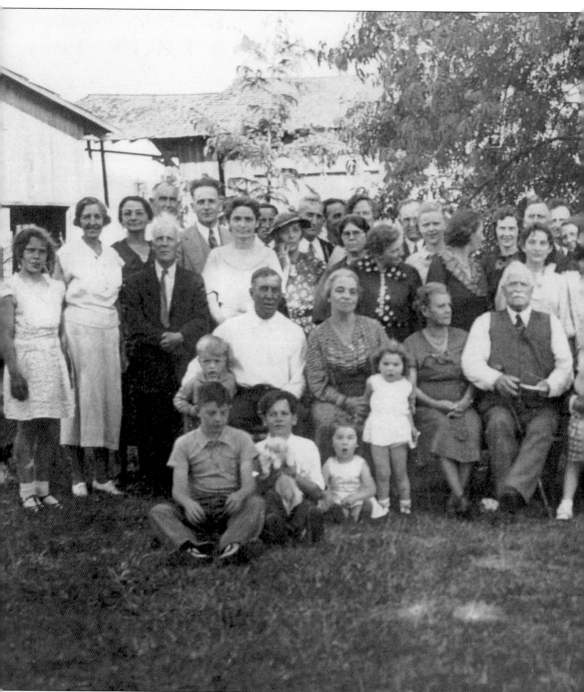

Pictured in the back row, left to right, are Robin Perrigo Norton, Anna Falconer Perrigo, Nellie Perrigo Morris, William "Buster" Ulmer (in dark suit), W.P. Perrigo Jr., and Marian Perrigo Ulmer (in white blouse). The three teen girls in light colored blouses in the middle of the picture are Glyneth Johnson Johnston, Willow Morris Guptill, and Elaine McMillian Watts. The man to the right of Elaine is Marve Perrigo, and directly in front of him is Matilda Perrigo with three of her great granddaughters playing at her feet. All the way to the left in the first row are Mark

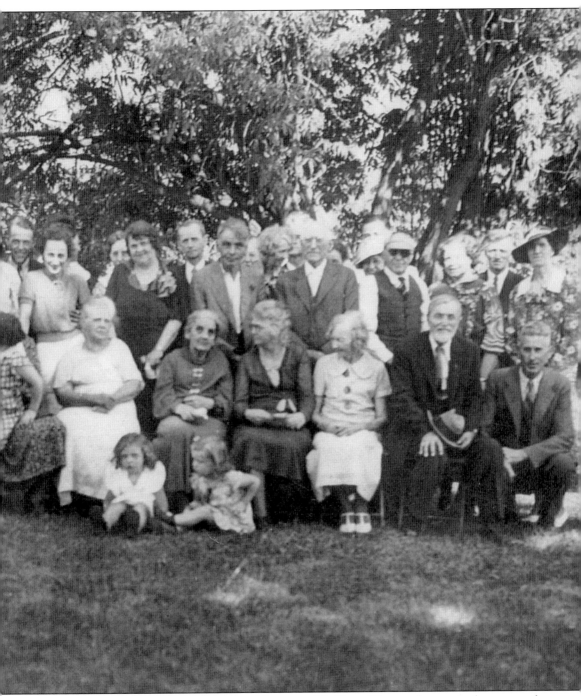

and Mable Perrigo Johnson with more of their grandchildren. The stately man in the center of the first row is Sam Hill. Mr. Hill's background was in railroads. His father-in-law and employer was head of the Great Northern Railroad. Sam Hill vowed that he would build a hard-surfaced highway from the Mexican border to the Canadian border, and all the way up to Vancouver, BC. So Sam Hill organized the Washington State Good Roads Association in 1901. William P. Perrigo was a founding member of WSGRA and knew Sam Hill well.

Redmond Wash Apl 27 1929
a substitute for Prohibition
By W. P. Perrigo:
all spiritous and malt
liquors to be manufactered
by the U S Government
or under government
supervision
To be sold at cost
in containers of one quart
and up
(Details of this plan to be
worked out by Congress)
This plan would put
all illicit liquors and
poisonous drugs off the
market
Would stop the importation
of all liquors from foriegn
countries
Would minimize the
number of paupers
insane and criminals
And in various ways
would improve the health and
morals of the nation
Would save many
millions of dollars
(which are now being
worse than wasted)
and would greatly
increase the wealth
and prospairity of the
whole country

This is a substitute for Prohibition by William P. Perrigo, written April 27, 1929.

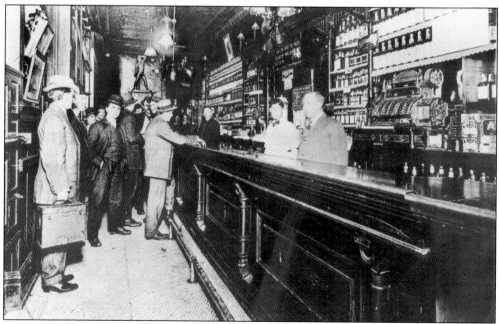

Pictured is Bill Brown's Saloon. Early Redmond taverns included Wiley's Saloon, the Corner Tavern, and the Eagle Bar. Bill Brown was Redmond's mayor from 1918–1948.

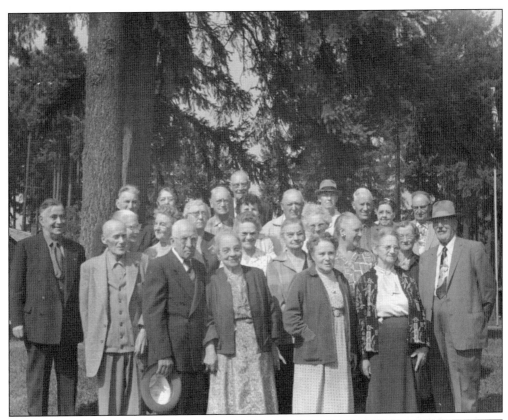

Pictured is the first Perrigo Pioneer Picnic held at Mark and Mable Johnson's home. The old Elderberry tree is in the background.

William P. Perrigo and Thomas Paine Perrigo served in WWI. Their brother Wells Perrigo died in 1918 of the flu epidemic.

65

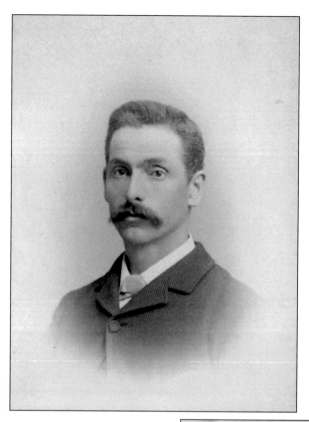

In April 1882 Thomas S. Provan, a slight, redheaded bachelor of 34, set out from London to see the world. Provan stopped in Belgium, Holland, and Denmark before sailing to New York. A skilled boilermaker, he worked for the railroad in Lincoln, Nebraska, and finally came to Seattle in 1883. Provan met Bill Williams who, for a small sum, promised to find him a homestead. Provan signed up for 160 acres of Northern Pacific land at $1 per acre. Provan met John Ware, who then committed to the adjoining 160 acres. He married Edna Griswold on May 1, 1889, in Seattle. Edna's wedding dress was brown wool trimmed in a shade of brown silk. They had three children, Ethel in 1890, Adeline in 1896, and Olive in 1899. Thomas Provan died in 1932.

Edna Griswold was the daughter of Isaac Herring Griswold, a Civil War veteran. Her mother died when she was eight years old. Isaac put his two children in an orphanage while he went to the Puget Sound to work. He sent for them when he reached 16. When Edna first came to Seattle, she worked for R.H. Thompson, Seattle's city engineer. She later moved to Redmond to join her brother, De Whitt, who was working for Warren Perrigo at the Melrose House. After marrying Thomas Provan she became postmistress of Avondale's post office, which was officially called White. Her father became Avondale's Justice of the Peace.

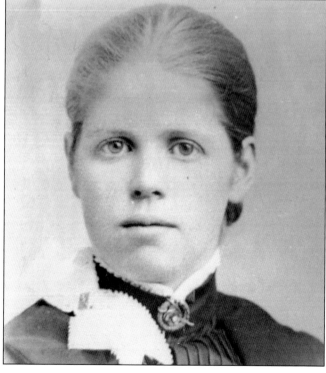

In 1884 four settlers made homestead claims of 160 acres each in Avondale: Thomas Provan, an English boiler maker; John Ware, an English blacksmith; John Sales, an Italian shopkeeper; and William H. White, a lawyer. They built cabins near the four corners where their land adjoined. The photograph to the right is of Thomas Provan's first cabin. The photograph below is of his second cabin, which is still standing.

W.H. White at this time was becoming a very popular lawyer. He had received some of his fame from his and

Orange Jacob's representation in the trial of the two men who were hanged for holding up and shooting to death George R. Reynolds at 3rd and Marion in Seattle. But he too wanted a farm, so he took up a homestead and in a few years he sent for his sister Mrs. Fulton and her son Walter to live on his homestead. Mrs. Fulton was raised in Virginia and had lived the life of a Virginia lady. Needless to say she found the pioneer life hard. Walter Fulton entered the University of Washington and with Judge White's assistance, books, and experience, became perhaps the most famous prosecuting attorney that King County ever had. Martha (White) Fulton was president of the Seattle Day Nursery and a co-founder of the Ladies Relief Society.

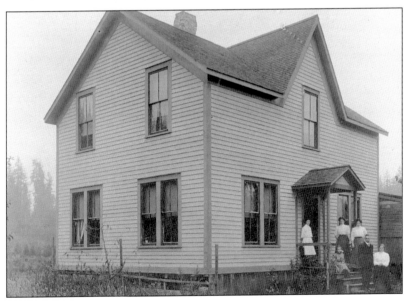

Winifred Wallace took this photograph about 1910. Olive is on the steps, while Tom Provan is in the dark suit next to Edna. The house was built in 1898.

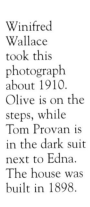

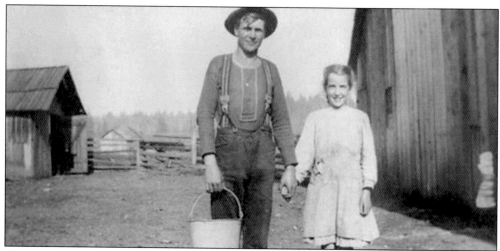

Olive Provan and a hired hand are doing chores on the Provan farm.

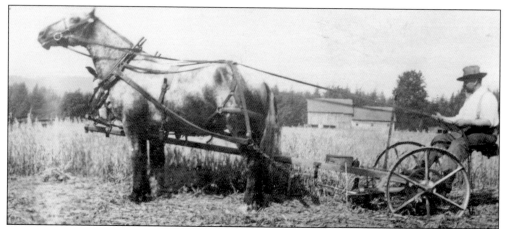

Mr. Lampaert is plowing his field near the present day QFC on Redmond Way.

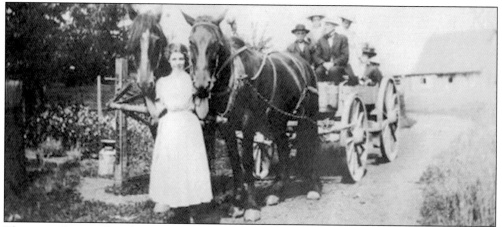

These people are off to church, from left to right: Addie (holding the horses), Thomas Provan, Olive, and friends.

Ethel Provan is shown here milking a cow while her father Thomas was away in Seattle.

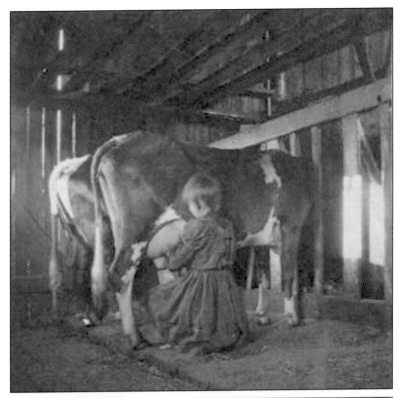

Broad-leafed maples bordered the Provan farm on the west. In 1930, Thomas and Edna Provan hired Winifred Wallace to take this photograph before the utility company cut down the trees.

Pictured left to right are unidentified, Miss St. Clair, Adeline, Olive, Ethel in suit, Edna in white blouse, and Thomas Provan on their ranch next to Avondale Road.

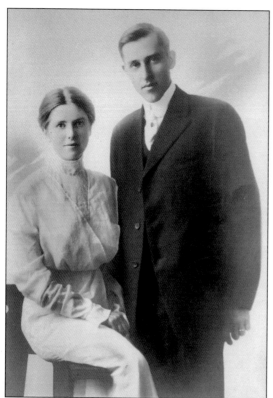

Ethel Provan was the oldest daughter of Thomas and Edna Provan. She attended Broadway High School in Seattle until Kirkland High School was completed and accredited. She was the first and only graduate of Kirkland High School in 1909. This was the closest high school to Avondale. She then taught school at Oak Harbor for two years, then Bryn Mawr, just outside Seattle, for two years. She met George Hebner at Bryn Mawr and they married in 1914. He was the son of Gustaf and Susana Hebner, both of whom were born in Germany. George became assistant superintendent of the Weyerhaeuser Lumber Company and Ethel later accepted a teaching position in Riverton. They lived in Issaquah, then Snoqualmie Falls.

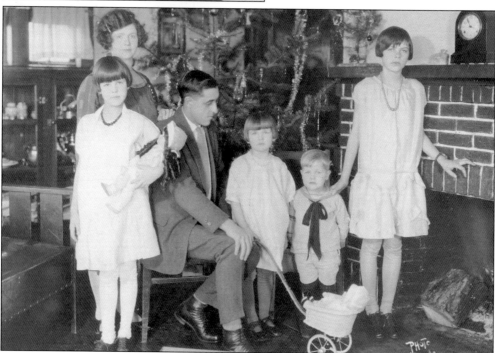

Pictured left to right are Suzanne, who is in front of Ethel, then George, Doris, George, and Edna Provan at Snoqualmie Falls, c. Christmas 1929.

Ernest Alexander Adams, born November 24, 1912, brought the population of Redmond to 300, enabling the town to incorporate as a city. He married Muriel Sanford on March 2, 1931.

In 1897, Ernest Alexander Adams was transferred to Redmond to work as District Supervisor of the railroad, supervising workmen from Woodinville to North Bend. In front of the living quarters provided by the railroad at the Redmond Railway depot, left to right, are: (standing) Mabel Adams, Webb Adams, and Alec Adams; (seated) Renie Farrel Adams and Ernest Adams. Kneeling with the family dog "Turk" is Jack Adams. Adjoining the living quarters at the station was the railway ticket office where Renie sold tickets for the daily train and operated the telegraph. Alec married Mabel Parks Adams. They were the parents of Ernest Alexander and Ray Adams. Mabel Annie Adams married Johnny Larson.

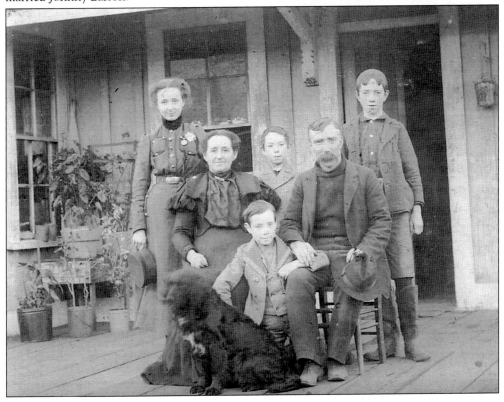

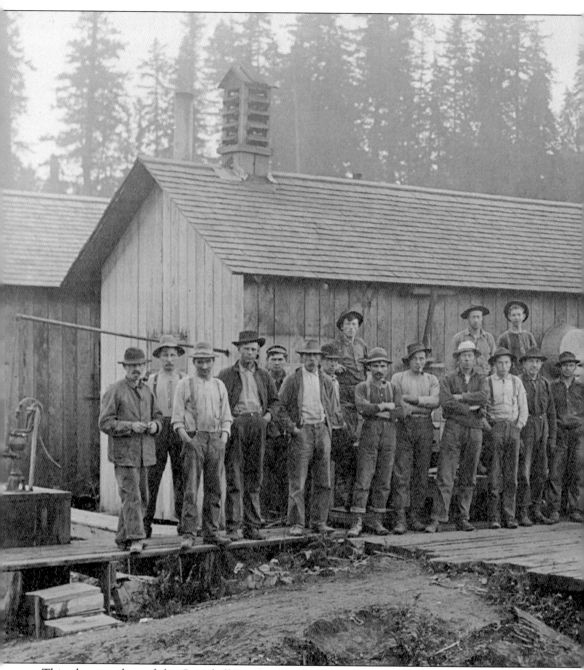

This photograph is of the Campbell Lumber Company's operations on the Provan farm. The photographer was Winifred Wallace and Bob Smith was the camp foreman.

Thomas Provan's 160 acres was logged in 1908 or 1909. He received about $3,000 for all the timber on his land. James Campbell and L.B. Stedman, under the name of the Campbell Lumber Company, opened a logging camp and mill in April of 1905 and did business on a large scale, starting with a capital of $50,000 and increasing it to $100,000 in 1907. By 1910 they had a company store, hotel, railroad depot, family houses, and 10 miles of logging railroad. The Campbell Lumber Mill was idle from 1912 to November 1915 when they hired 100 sawmill

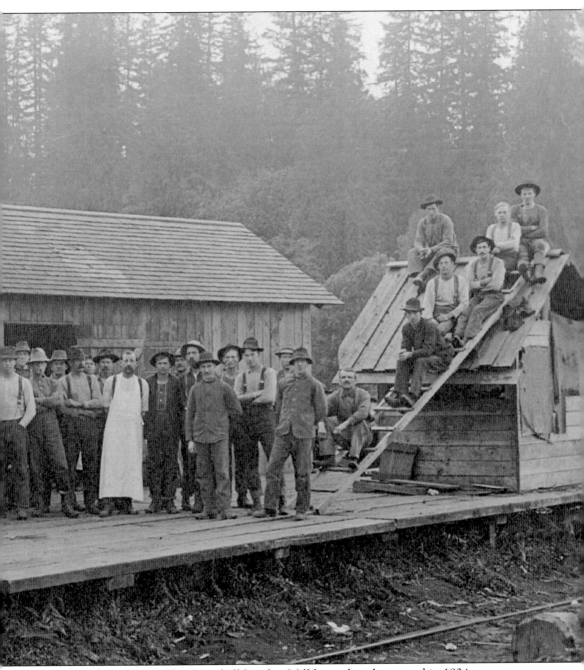

hands and 25 planers. The Campbell Lumber Mill burned to the ground in 1924.

In 1909 the Redmond Lumber Company was formed by E.S. Barnes, Walter Gammon, and J.T. Peterson. The company was capitalized at $25,000, and for some years ran a mill of 50,000 feet daily capacity. The Ohio Mill, with 25,000 feet capacity per day, ran at the same time. On January 31, 1918, the Redmond Logging Company, incorporated by Jesse, William, and L.D. Brown, started with $30,000 capital and operated for several years. The Lake Sammamish Shingle Company, founded at Monohon in 1901 by J.F. Weber, Henry F. McClure, and R.M. Castle, employed from 30 to 40 men.

Ernest Alexander Adams is pictured here in front of Oscar Blau's Tavern and Pool Hall in Redmond. This building was originally the Eagle Bar built by O.A. Wiley and later the office of the *Sammamish Valley News*.

About 1902, Ernest Adams' brother, Arthur Gordon Adams, moved to Redmond with his wife, Annie May Farrel, the sister of Ernest's wife Renie. Their children were Wilson Ernest Adams, Archibald "Archie" Adams, and Dora Pearl Adams. Standing is Wilson Ernest Adams, born 1892, and his mother, Annie May Farrel, who died in Redmond in the early 1920s. Wilson Adams married May Parks Curtis, a daughter of David Alonzo Parks who kept the livery stable in Redmond. This photograph of the Redmond-Kirkland stage office on the corner of Leary and Cleveland Streets was taken about 1922.

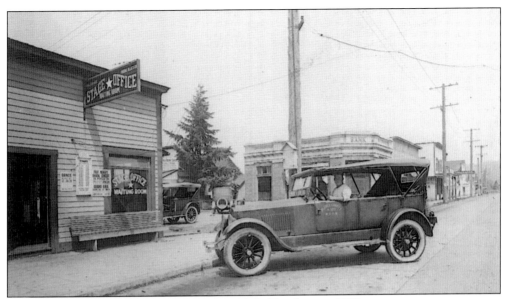

Wilson Adams is pictured here in a Redmond-Kirkland stage, 1922.

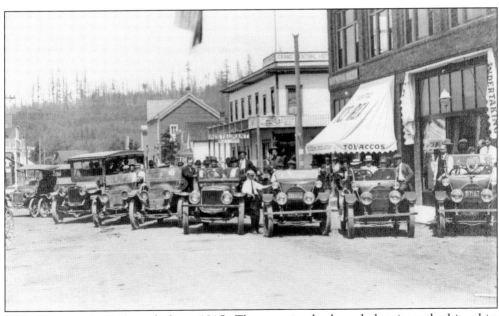

Old stage cars in Redmond about 1915. The man in the hat, dark suit, and white shirt standing on the 5th car from the left (directly under the NT in restaurant) is John Quincy Adams. The awning with Tobaccos is part of the Bill Brown Building. The Grand Central Hotel is next door with a balcony.

This picture of the Adams house was taken about 1909, while the house was quite new. The house was built during the summer of 1908 at 16540 NE 77th Street, Redmond. At that time the street was called "Railroad Avenue." It stood opposite the old Luke McRedmond farmhouse. When the Adams family moved into this house in 1908, it was the first house in Redmond to have electric light switches. The evening of the day the Adams family moved in there was an impromptu open-house as people from all over town came to push the buttons and to marvel at the spectacle of lights going on and off with so little effort. About 1940, Mabel Adams Larson sold the house to Claude and Marie Matthews. The house burned during the evening of February 7, 1969.

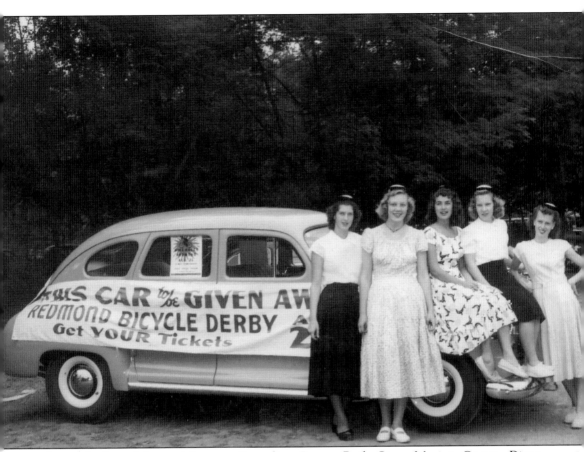

Pictured, from left to right, are Bernadine Porter, Ruth Sires, Maxine Crouse, Diane Hollingsworth, and Jeanne Mathews.

The history of Redmond Derby Days is traced to the late 1930s when bets were made on bike races. Ray Adams, who had the *Seattle Star* paper route, and Charlie Lentz, who had the *Seattle Times* route, were among the fastest cyclists around. In the beginning, Ray Adams raced Charlie Lentz, Roy Buckley, Johnie Anderson, Robert Anderson, Eric Anderson, and other kids around the block. Someone decided they should race around Lake Sammamish, which was even more challenging as the eastern side was not paved. Later, in 1939, when the Derby Days were organized as a community fundraiser, the idea of selling tickets for a chance to guess the winning race time started the tradition.

The civic-minded citizens at the 1939 organizing meeting included Oscar Blau, Buster Bryden, Frank Buckley, Clarence Fullard, Hazel Kerwin, Ernie Johnson, Ray MacComber, Grace Thomas, and Helen Peterson. To fund the project, Oscar Blau offered $100 and Frank Buckley agreed to match with an additional $100. Betty Buckley Anderson became Derby Queen by selling the most tickets.

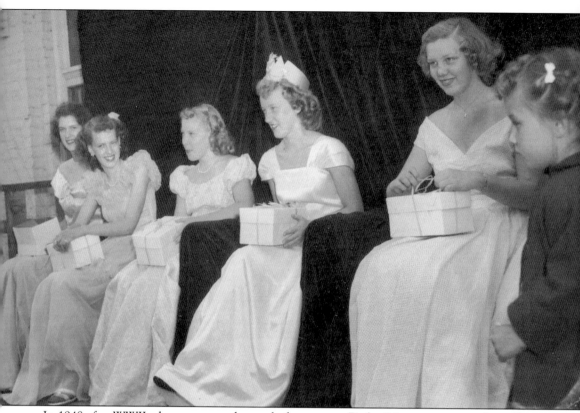

In 1948 after WWII when everyone dreamed of a new car, Derby Princesses competed to sell as many raffle tickets for the car. The princess selling the most tickets was crowned Derby Queen.

The 1948 Redmond Bicycle Derby began with a parade of children in costume and the crowning of the Derby Queen, Diantha Reese. Princesses accompanying her reign were, from left to right, Bernadine Porter, Jeanne Matthews, Diane Hollingsworth, Derby Queen Diantha Reese, and Ruth Sires. Not visible is Maxine Crouse. The bicycle race, run under the rules of the National Amateur Racing Authority, began in the early afternoon, with classes for men and junior and senior boys and girls. Junior riders raced from Issaquah to Redmond, and senior riders raced the 25-mile route around Lake Sammamish.

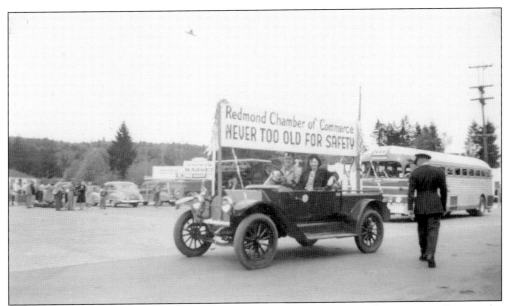

Bill and Joyce Maudlin Virgin are seen here riding in a Chamber of Commerce float in the safety parade. Harry's Market is in the background. Harry Carlson built frozen food lockers behind his store. The lockers were rented by literally half of Redmond's families in 1945. The market's open façade had hinged doors which were closed at night to secure produce and merchandise displays. Harry's Market also boasted a lunch counter where Harry's sisters-in-law, Agnes and Anna Johnson, served home made pastries and ran the first soft-ice cream machine in town. Later the store became known as Clint's Market when Clint Lochnane bought it, then Barry's Market when Prescott Barry bought it.

Pictured is Ruth Sires on her horse with her brother Russell L. "Pinky" Sires Jr. In 1937, her uncle gave her the 1930 Model A Ford in the picture as a graduation present.

SIRES

R·O·M R·O·P

HATCHERY & BREEDING FARM

PULLORUM CLEAN

In Avondale

ROUTE 2 WOODINVILLE, WASH.

Phone Redmond 8585

This was the logo for the Sires Hatchery and Breeding Farm in Avondale. Prior to moving to Avondale in 1940, Mr. Sires was employed at Seattle Gas Company where he had organized and become president of the Gas Workers Union in the Great Depression. On the day the Sires family moved from the city to the country, a cow was delivered. Mr. Sires promptly left for work in the city, leaving Mrs. Sires, a city girl with no prior bovine experience, to milk the cow. Mr. Sires continued to work in the city with a long commute prior to the building of the bridges across Lake Washington, until Mrs. Sires announced that she was making more money farming than he was at the Gas Works. So at the age of 36 he became a full-time farmer, operating an experimental farm in cooperation with colleges from WSU to Amherst College, with the goal of producing disease-free, highly productive birds. Their baby chicks were sent air express worldwide. Mr. Sires became president of the National Farmers Union. As president of Redmond Chamber of Commerce, Mr. Sires suggested the slogan of "Where Business and Pleasure go together." Mrs. Sires was also a newspaper columnist for *Sammamish Valley News*.

Panfilo Morelli is shown holding a chicken. He was named for his grandfather, Panfilo Morelli. His grandmother and mother were both nambed Albarosa. The children of Silvio and Albarosa Morelli are Elisa, Panfilo, Dante, and Robert.

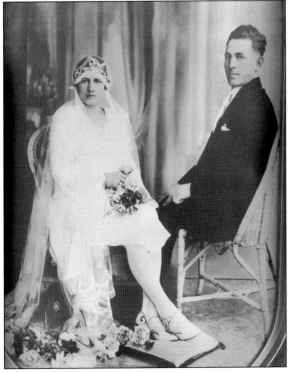

These are Panfilo's parents Silvio and Albarosa Morelli on their wedding day. Silvio and Albarosa were born in San Gregorio, Aquila, Italy. Her first name means "While Rose" in Italian. She loved roses and had a way with landscaping around the house so the flowers looked perfect. She came to Redmond in 1932 with her husband. Silvio died in 1979. Albarosa died April 3, 1999. In 2000, Silvio and Albarosa's home was moved less than a mile north on 148th Avenue, north east, by their sons.

Pictured are Alfonso, Matteo, Martino, Silvio, and Tito Morelli.

These are the Morelli Brothers and their wives: Albarosa, Silvio, Alfonso, Dominica, Martino, Loretta, Ida, and Tito.

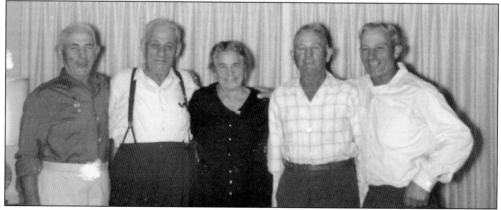

Silvio, Alfonso, Turinda, Martino, and Tito Morelli are pictured here. Their sister Turinda was visiting from Italy. The brothers lived together on their large farm, sharing work, profit, and times, raising their children as one large family.

Silvio Morelli is pictured with son Panfilo Morelli on the chicken farm. The Morelli Brothers worked their way across the United States by working in coal mines, mining shafts, building railroads, and construction in what were then small population centers. Some projects lasted a few years. About 1910 they moved west and put in drainage for railroad tracks at Stampede Pass. The Morelli Brothers poultry farm was established in 1915 by Albert E. Hammond. Al Morelli joined forces with Mr. Hammond in 1919. This partnership continued until 1923 until Al bought out Mr. Hammond's interests. Then brothers Martin, Silvio, and Tito joined him. By 1940 they maintained over 10,000 laying birds. This grew to almost 15,000.

Puget Sound Energy used this photograph, taken in 1940 by Asahel Curtis, in advertisements. The Morelli farm was the first one on the Eastside to use electricity to increase productivity. The

henhouses had light on timers, turned on automatically at 4 a.m. so the hens would lay more eggs. The over-60 acre farm on 148th Avenue NE was later divided near NE 60th Street.

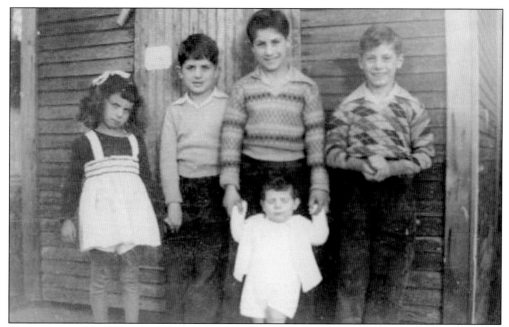

Pictured from left are: Anna, Dante, Panfilo, and Tito Morelli Jr. Robert Morelli is the baby in the front. Dante and Panfilo are his older brothers. Anna and Tito Jr. (who later became a dentist) are children of Tito Sr., who was the inventor of the family.

Tito Morelli Sr. epitomized the transition from the Old World to the new. He was born September 14, 1897, in San Gregorio, Aquila, Italy, the youngest child of a family of nine. When Tito was 18, he followed his four older brothers as they worked their way across the United States and settled in Redmond. Tito held many patents. When he was not actively involved in working for the farm, he dreamed of developing a perpetual magnetic motion machine. For 30 years he worked on this idea in his free time. People said his gentle spirit, visionary drive, hard work, and integrity inspired everyone. Tito kept the farm going until the 1970s, when a couple of Great Danes got into the chicken houses and killed most of the hens. Tito, then in his 70s, tried to fight one off with a pitchfork, but was saved by his nephew, Dante Morelli, who shot the dog while it was standing over Tito. The incident was reported nationwide, including on NBC's Huntley-Brinkley report.

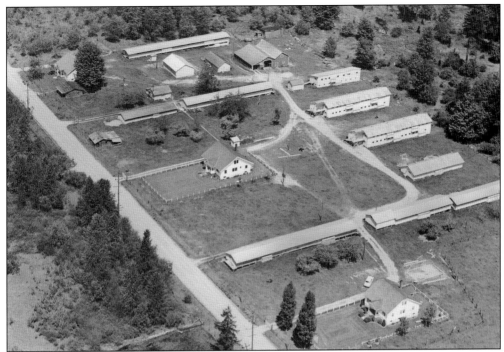

This is an aerial view of the Morelli homes. The first house with the tree, at the top of the photo, was Alphonso and Dominica's, built in 1929. The middle house was Martino and Loretta's, built in 1935. The next house was Silvio and Alba's, built in 1936. Not pictured is Tito and Ida's identical house across the street, which was built in 1955. The farm was on unincorporated King County property until it became Redmond in the 1990s.

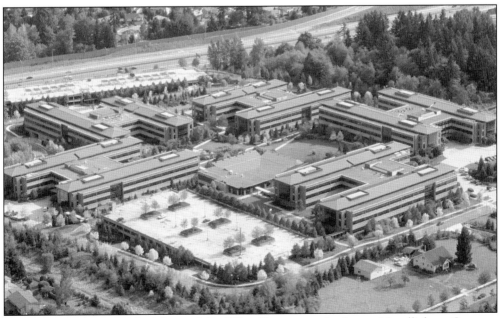

This is an aerial view of the Microsoft RedWest Campus on the former Morelli farm. Courtesy Microsoft Corporation. Martino Morelli's house is in the foreground.

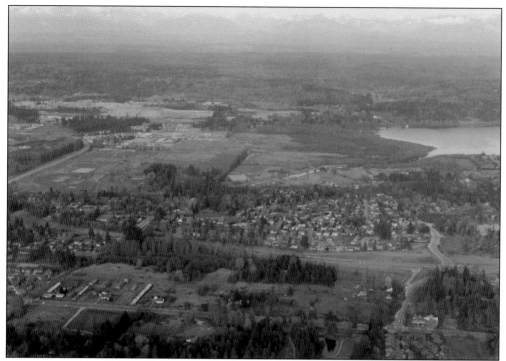

An aerial view includes the Morelli chicken farm, three houses, Lake Sammamish, and Marymoor, where the Tosh barn on the following page was located.

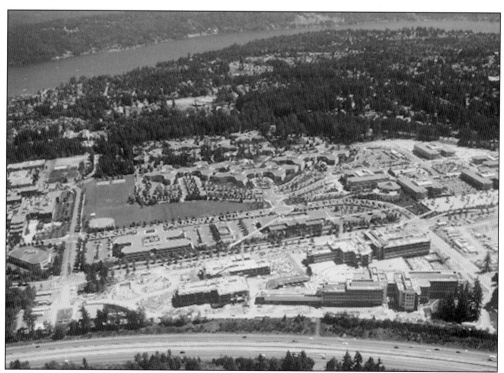

This is Microsoft's main campus in 1997. Courtesy Microsoft Corporation.

Two

Land and Buildings

The *Daily Intelligencer* of September 1, 1876, reported: "From L. McRedmond, who was in town yesterday, we obtained the following information. On the Sammamish River and its tributaries there are 5,000 acres of rich bottom lands, principally beaver dam covered with a growth of willows. A large tract of this belongs to the government and is subject to preemption and homesteading. The first settlement in this district was made six years ago; at that time only three claims were located on the river. Now there are 25 claims occupied by their owners and six partially improved by absentees. McRedmond is near the bend of the river, within two miles of Squak Lake. He has 30 acres cleared and will have 10 more this year. He has 200 assorted fruit trees and a number of grapevines. He has raised excellent wheat and oats. Eight new houses were built on the river this summer and 250 acres of wild land will be cleared. A good schoolhouse has been built and school is conducted six months of the year. There is a great need for transportation."

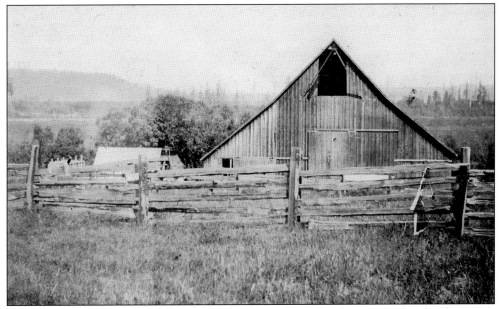

Pictured above is the Tosh Barn built in the 1870s next to the Sammamish Slough. The center section of the barn was used for storing hay. The outside edges were for the cows when they were being milked. The floor had troughs to put hay in, to keep the cows quiet when they were being milked. The milk was put in large cans, and kept in the milk house that was next to the barn. Tosh Barn was located on what is now Marymoor Park. A news article stated that Metro planned to tear the barn down to make way for a sewer line but decided to go around it after learning of its historical importance.

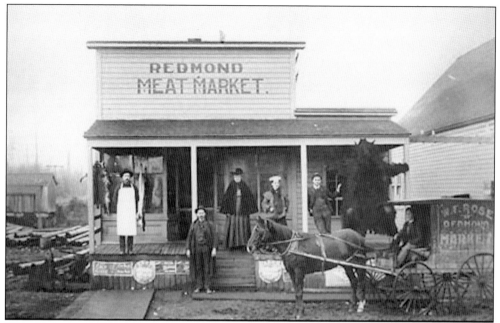

W.R. Rose was the proprietor of this early Redmond Meat Market, photographed here *c.* 1890. The market was located where the Redmond Trading Company was built in 1908.

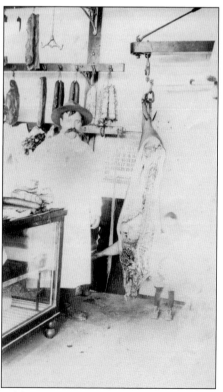

Adile Lampaert is in his butcher shop while his four year old son, Roy, stands in front of Skjarstad Shoe Shop in 1914. The butcher shop, which is now a beauty salon, was next to the shoe store.

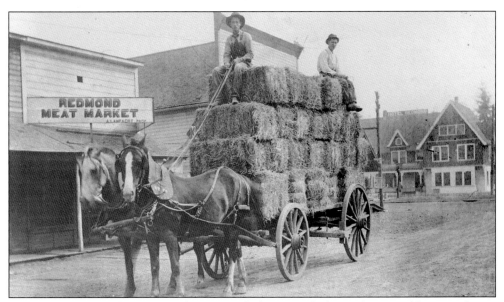

In this photo taken about 1907, a hay wagon hides most of what is the second location for Ted Youngerman's Feed Store. To the north is Adile Lampaert's Meat Market at its first location. The Hotel Redmond is in the background.

Pictured below is Ted Youngerman's General Store, with Ted Youngerman on the left, c. 1916. He was born September 15, 1861 in Ohio, and lived for a while in Abilene, Kansas before coming to Redmond. When the Adams family came to Redmond in 1897, Mr. Youngerman was operating a hay and feed store at the corner of Leary and Clevelend Streets, across from where the bank was later built, on the corner where later the stage depot was. At that time he roomed and boarded with the Luke McRedmond family. He later expanded his hay and feed store to a general store on the corner of Leary and Railroad Avenue, across from and in competition with Huffman's Redmond Trading Company. He became a close friend of the Adams family and was known to the Adams children as "Uncle Ted." After Alec Adams married Mabel Parks in 1912, Mr. Youngerman lived in the Adams house, boarded there, and

was practically regarded as a member of the family. Ted was elected to the first Redmond Town Council in 1912. He was a humane businessman with a generous nature, and he developed a faithful patronage. Mabel Adams worked for him, keeping his books, buying, and clerking. He died in Redmond on March 26, 1925.

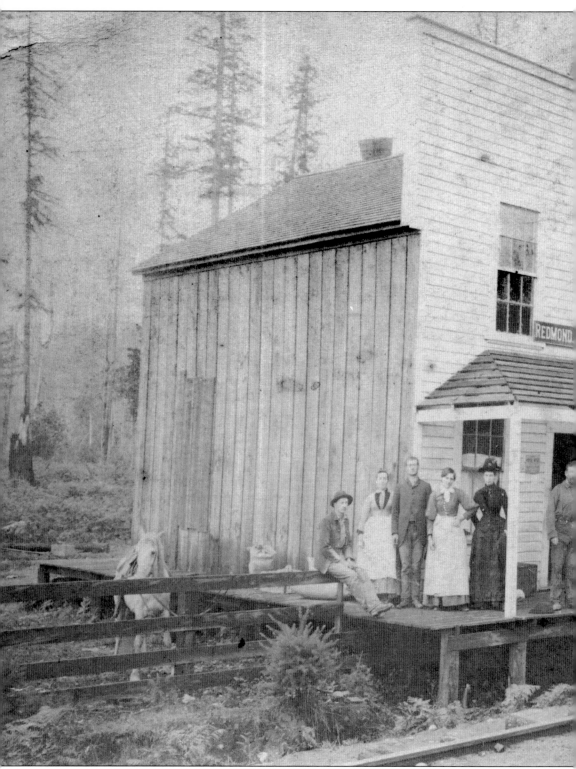

Emma was probably still postmistress in this photograph of the Redmond post office. Some of

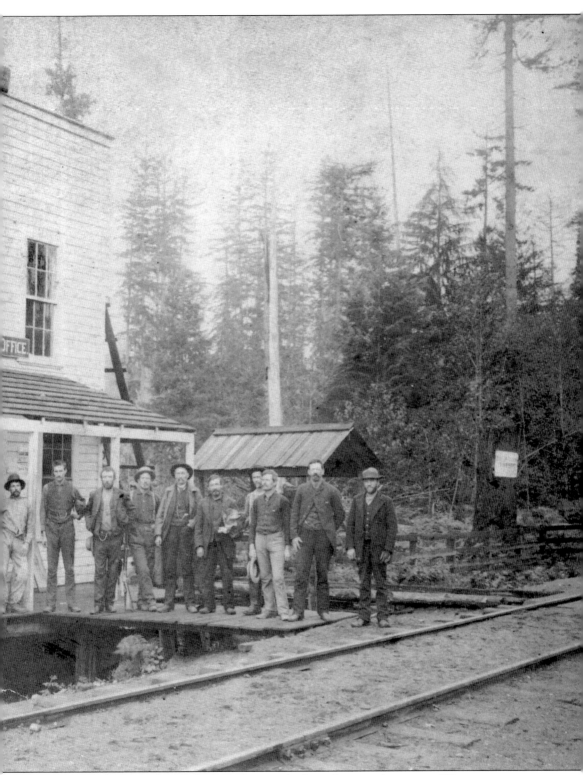

the people here are also on the train station platform photograph on page 108.

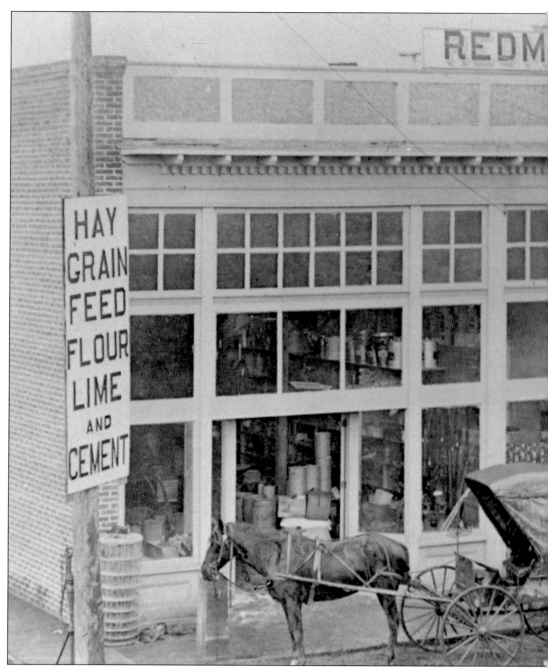

The next postmasters, dates of appointment, and some of the locations were: Emerson G. Miller, January 26, 1898; Mathias Munson (uncle of Irene Westby Brown), December 5, 1899; William A. Faulds, February 18, 1902, moved to Redmond Trading Company; Henry A. Templeton, (William Fauld's son-in-law) February 23, 1906; and Frederick A. Reil, October 10, 1907. When the mail came in by train, F.A. Reil put the mail in a wheelbarrow and toted the precious cargo across the street to the Redmond Trading Company. Herman S. Reed was postmaster from February 17, 1915 until his death in 1933. He had bought the T.B. Westby mercantile establishment and moved the post office into his business located one door east of

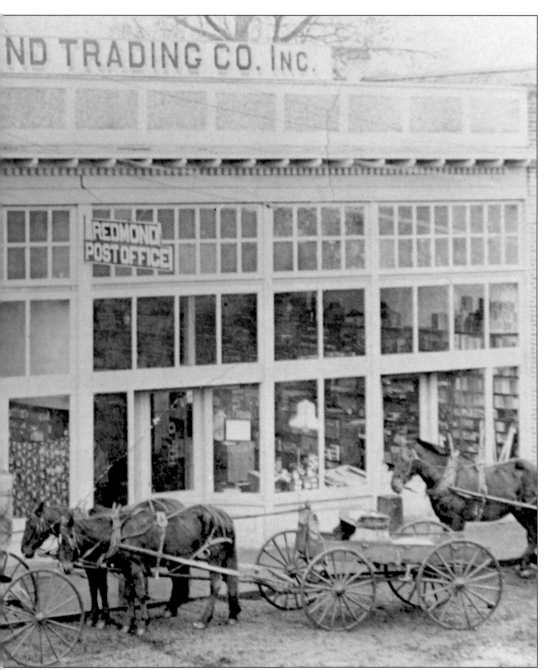

the Redmond Trading Company. The next postmasters were: Leo B. Reed (son of Herman S. Reed), May 4, 1933; Mrs. Addie B. Reed (interim appointment), March 16, 1933; Leo B. Reed, June 7, 1938; Robert E. Olney, August 24, 1956; Robert N. Plumb, August 18, 1966; Kenneth Johnson, November 7, 1975; and Patrick John Ogle, December 3, 1982. Our current postmaster is Les Stuart. The Redmond Post Office was selected to be a "First Day Cover" office in 1988 when a new stamp commemorating the tandem bicycle was released to the public. Redmond was chosen, as it is known as the bicycle capital.

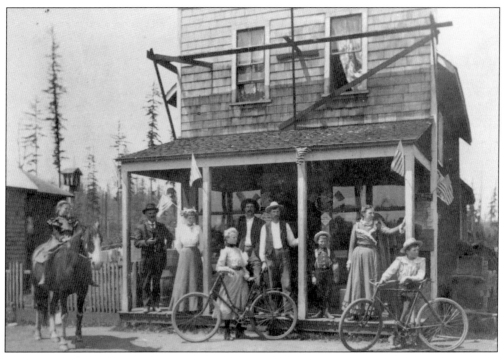

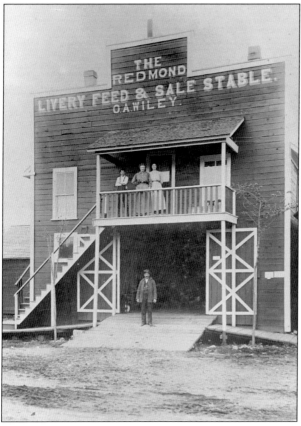

Irene Westby Brown is shown on her horse in front of her father's store, T.B. Westby Dry Goods. Others are (left to right): Mr. McKay, owner of the Corner Tavern; Mary Davis; Mildred Bergum with bicycle; Harry Martin; T.B. Westby; Allen Westby; Mrs. T.B. Westby; and Roy Westby. The identification comes from a newspaper clipping that also states the photo was taken about 1901. T.B. Westby was postmaster. When Irene was interviewed, she recalled Saturday night dances followed by midnight lunches at the Justice White house. Irene later drove a Redmond-Kirkland stagecoach.

The O.A. and Emma Holmes Wiley family lived above their livery stable until their stone house was built next door. Wiley later built the Eagle Bar next to it.

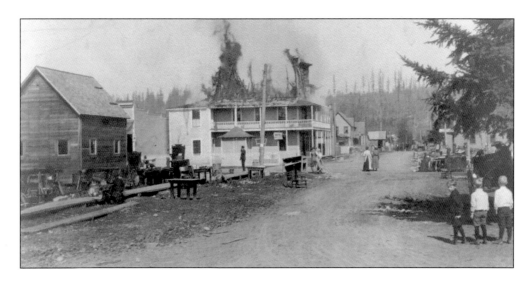

The Hotel Walther fire occurred on March 13, 1910. Fire was a constant threat as the fragile wood-frame structures were heated with coal and wood-burning stoves. This snippet comes from the 1960 Redmond Jr. High History project, quoting Judge Reil: "We had a big fire. To stop the fire we had to blow up a building. The main reason for incorporation was to get a water system." Like many other King County municipalities, Redmond some years ago began the operation of its own water works. The town has controlled its water supply from the start. In 1913, following incorporation, the town took steps to replace the old time wells with a modern system. In 1914 the taxpayers bonded themselves for $13,000; this was augmented by a $27,000 bond issue in 1927. All of this has been put into the water system, which is now valued at $51,890.58 and includes 200 acres of land. Several springs about four miles northeast of town are the source of supply and an abundance of water is assured by two reservoirs, one of 210,000 gallons and another of 250,000 gallon capacity. There are 165 taps and the annual income totals more than $41,000.

Reil was postmaster then, appointed by Teddy Roosevelt. He was naturally selected to be the first mayor. He served three terms and retired, undefeated, when he began a trucking business to Seattle in 1919.

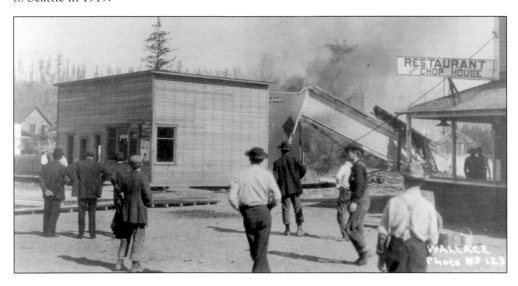

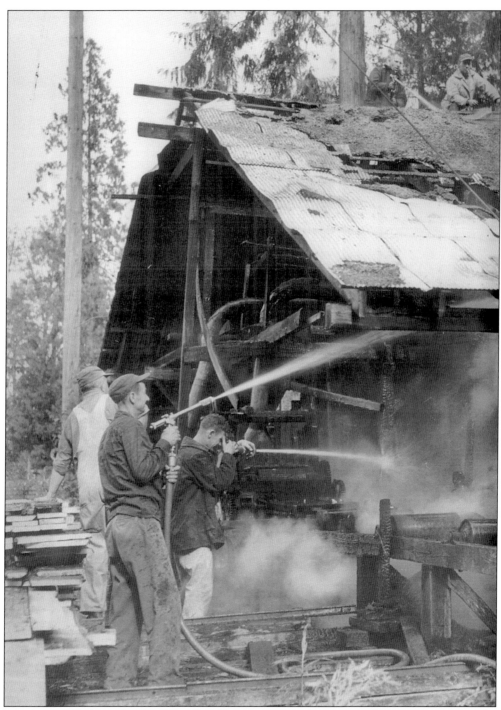

Members of Redmond's Volunteer Fire Department at Steven's Mill on 40th above Lake Sammamish are Charlie Riel, in white overalls, and Adolf Radtke with the water spray next to him. On the roof are Euc Labrie on the left, and Jan Foreman on the right holding the water spray.

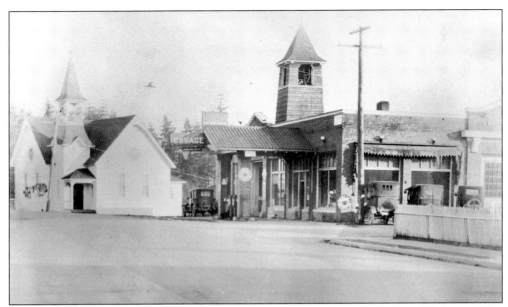

Pictured is Mayor Bill Brown's garage and the Methodist church on the corner of Redmond Way and Gilman Street. Atop the garage was a tower with a bell that was used to call Redmond's volunteer firefighters to action. The church was moved to NE 80th and 165th Avenue NE.

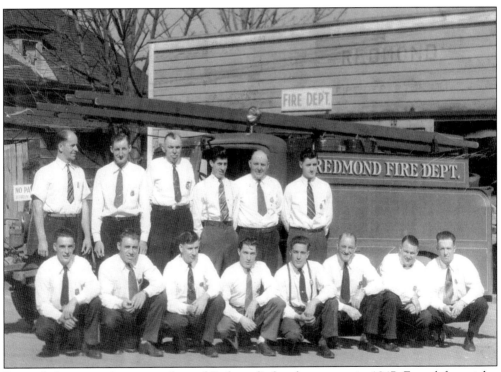

Pictured above are charter members of Redmond's fire department in 1947. From left to right, the men pictured are: (back row) Clarence Barker, Ed Rosenthal, Ben Kuppenbender, Woodward Reed, Al Irish, and Ward Martin; (front row) Andrew Forcier, Joe Mellquist, Daryl Martin, Bud Entrican, Ralph Frocier, Clarence Fullard, Chief Jack Buckley, and Assistant Chief Charley Reil.

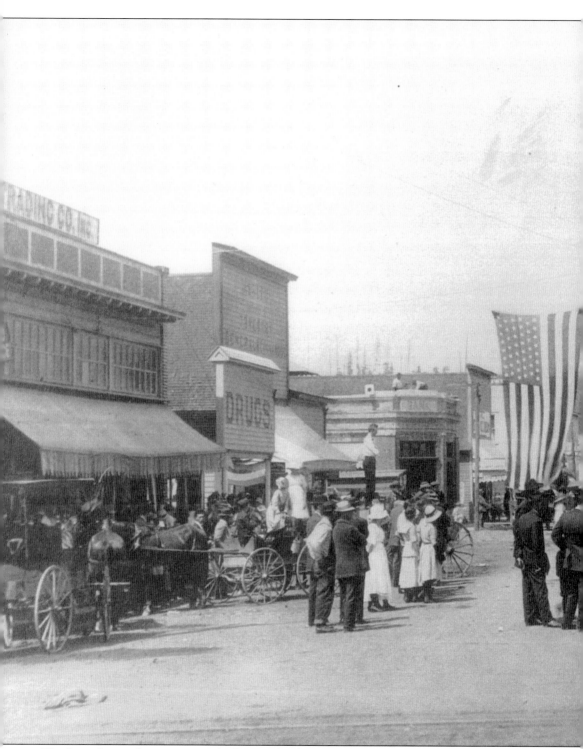

The log cabin in the center was the home of Luke McRedmond's stepson James Morse, who homesteaded 160 acres. An Arco station is now located there at the corner of NE 80th and the Redmond-Woodinville Highway. In 1889 James was serving on the school board when

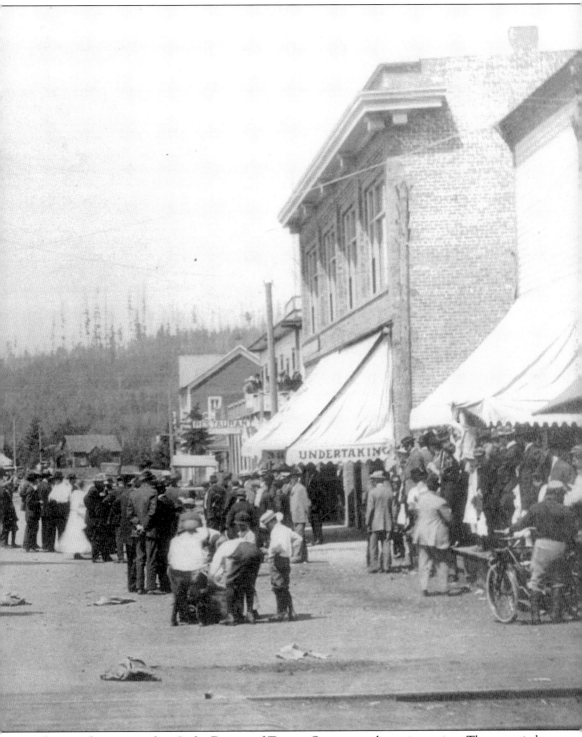

he met the new teacher, Lydia Denyer of Turner, Oregon, at the train station. They married in 1892 and had three daughters. This photograph was taken after the Redmond National Bank was built in 1911.

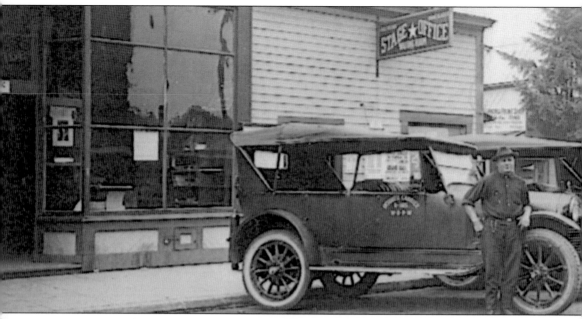

The top picture is of Leary Way, facing north with Adile Lampaert's meat market at its second location, two buildings after the Bank. Thomas Brothers purchased the meat market as shown in the bottom picture, facing south.

This snippet comes from the Redmond Junior High History Project:

The Northern Pacific Railroad operates a single-track freight line through the town, over which four trains run daily, two each way, carrying out shingles and farm products, especially lettuce and bulbs, and bringing in feed, hay, and other commodities. Most of the dairy produce leaves Redmond by truck. The town is reached by several good highways that connect with all parts of the state. The county road runs to Woodinville, 8 miles, and to Bothell, about 10 miles, and other

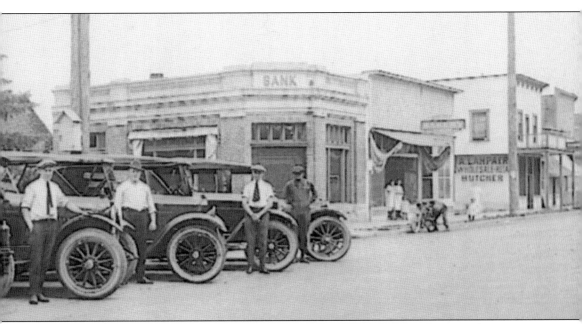

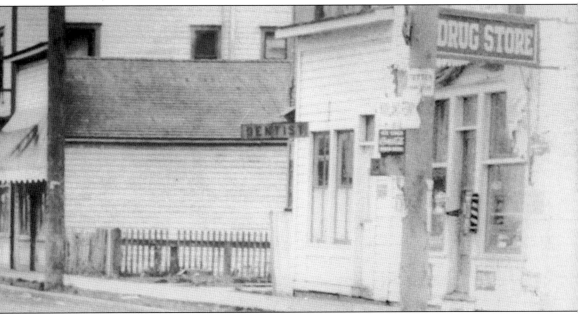

northern points. A new highway was completed recently covering the 4 miles between Redmond and Kirkland, cutting off a mile and a half from the distance over the old road to the south of it. This thoroughfare was opened with ceremonies on November 12, 1927. It is said to be the only county road in the state with "super-elevated" curves; these give it the same traction as a straightaway. Rapid automobile transportation between Kirkland and Redmond was established on November 7, 1911, with the incorporation of the Redmond-Kirkland Auto Stage Company, under direction of A.N. Brown, William Brown, and Charles Brown. The concern had capital stock in the sum of $3,000. A new automobile road to Fall City and other points along the Snoqualmie River, with North Bend as a terminal, is now under construction. When completed, this road will cut off about a mile; it was begun in the summer of 1928.

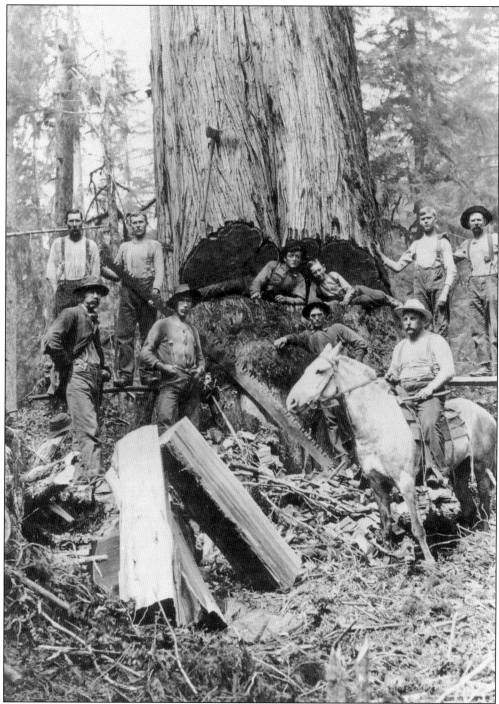

Pictured is Siler's logging crew on Union Hill in the 1920s. Siler's was the largest operation in the Redmond area, employing 200 men. Trees were felled using axes and crosscut saws while fallers stood on springboards. Old growth forests contained Douglas Fir, Western Red Cedar, and Sitka Spruce, which was sometimes too large in girth to be sawed and were felled by burning their trunks above the roots.

Three

TRANSPORTATION

Good forests stood on the site of Redmond and extended thence to the shore of Lake Washington. Logging in the early days was done by cattle. It was necessary to log only fairly level land, as cattle are not adapted to hills or to muddy roads. According to early residents, it was not unusual to see teams of up to 12 oxen hauling logs to nearby loading areas and sawmills. Some of these logs measured up to 17 feet long and 8 to 10 feet in diameter. Horses succeeded cattle, and were a great improvement. Steam donkey engines with railroad equipment in turn succeeded the horses, and the use of logging trucks made almost obsolete the equipment of rails and engines and cars. Before the construction of the railroad, William Houghton began logging in the early 1880s and William Cochran, also, was an early logger. The building of the Seattle, Lake Shore & Eastern Railway through the Squak Valley opened up this area to the loggers. John Peterson built the first sawmill about 1890 and a certain Donnelly operated a mill first on the west shore of Lake Sammamish and later on the site of Monohon. High rigging was the order of the day in any good-sized camp. A tree was selected which was used to yard all the timber within an area of 1,300 feet. A man climbed a tree which was 200–300 feet high, a rope fastened to his belt completely encircling the tree, and as he "hitched" the rope up the tree, he cut off all limbs as he climbed, often going two or three times around the tree on his way up.

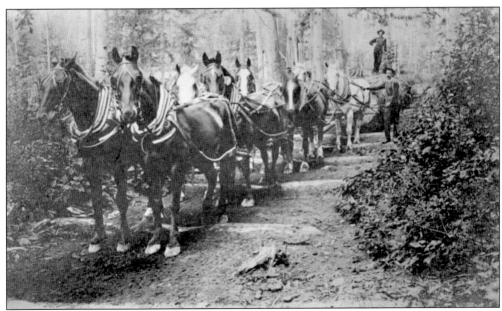

In the background you can see the skid road. Workers built skid roads by placing smaller logs, called skids, across the uneven, muddy path. A crewmember greased the skids to make it easier to drag the heavy logs along the road.

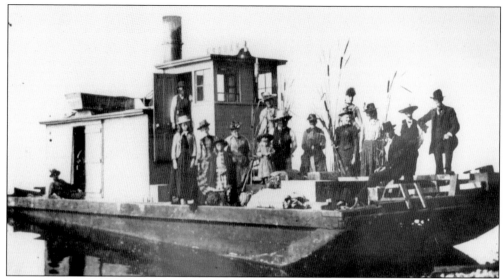

Starting in 1884, the steam-propelled scow *Squeak* made biweekly trips between Laurel Shade Landing (south of Madison Park) up Lake Washington and along the Sammamish Slough to Tibbits Landing, now Issaquah. Passengers could get on or off at Juanita, Bothell, Woodinville, Redmond, and other landings along the route. The scow's shallow draft made it easier to navigate over sandbars and logs in the slough. The camping party, having harvested cattails and other frivolous items, is shown here upon embarking aboard the steamer *Squak* after a two-week camp-out at what is now Juanita Point. Reclining in the engine-room doorway is Capt. J.F. Curtis. Left to right, are: (front row) Fanny Kirk, Mrs. J.F. Curtis, Mrs. Kneisel and daughter, M.L. Baer, Mrs. T.H. Duncan, Maud Frederick, Gertrude Duncan, Ben Wright, Al H. Curtis, and T.H. Duncan; (back row) Olive and Marie Kirk. This photo was taken in 1890.

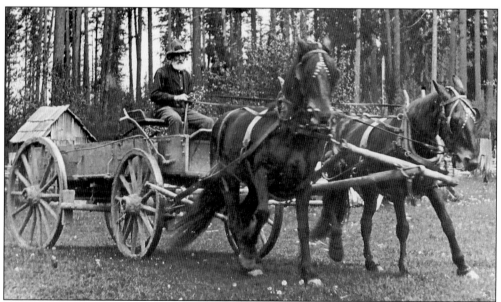

According to Mrs. Martin's diary, the Martin and Perry families arrived at Lake Sammamish River on May 2, 1883. John Martin, pictured above with his team of Diamond and Bess, had 10 children. Grandchildren include Daryl and Ward Martin, charter members of Redmond's fire department.

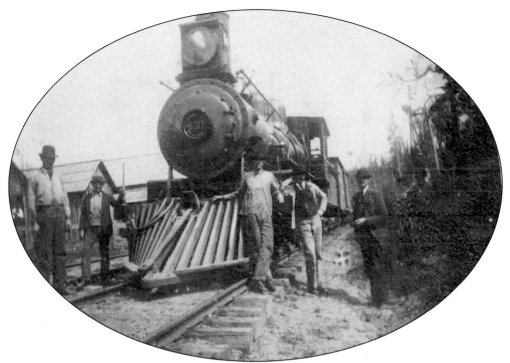

The handwriting on the back of the original picture is hard to read, but the guess is: "Engine 15, Seattle Lake Shore & Eastern Railway, Preston, WA. Elmer A. Smith, Conductor, C. Hartman, Engineer, C.V. Smith, unidentified, Brakeman, William (?), Fireman." Preston is near Redmond and had a logging operation. C. Hartman is possibly Conrad Hartman, early landowner listed in the 1880 census.

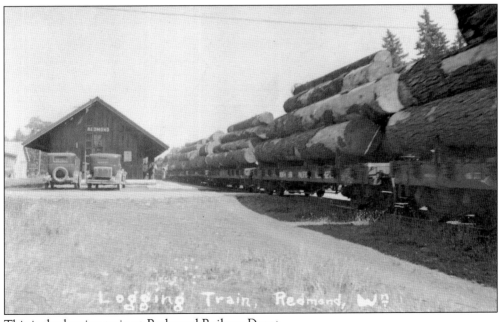

This is the logging train at Redmond Railway Depot.

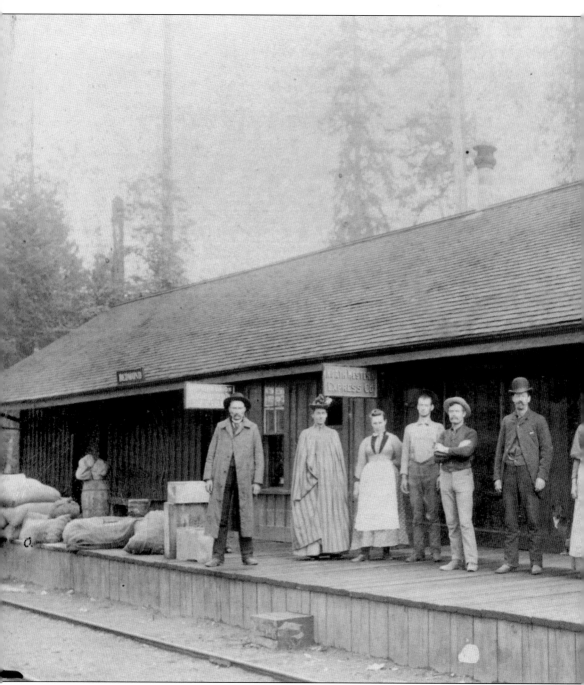

In April 1884, at Judge Burke's speech, Judge "Warhorse Bill" White was nominated to convince Congress that Seattle should become the western terminus of the Northern Pacific Railroad. The people at the speech passed a hat collecting $729 to send Judge White on this mission. The *Tacoma Ledger* derisively dubbed him "729 White." His mission was to urge upon Congress the forfeiture of the unearned land grant of the Northern Pacific Railway. Col. William F. Prosser in "His Love of the Puget Sound Country" said: "This commission was executed so well before the committees on public lands of the senate and house that the result was to hurry the completion

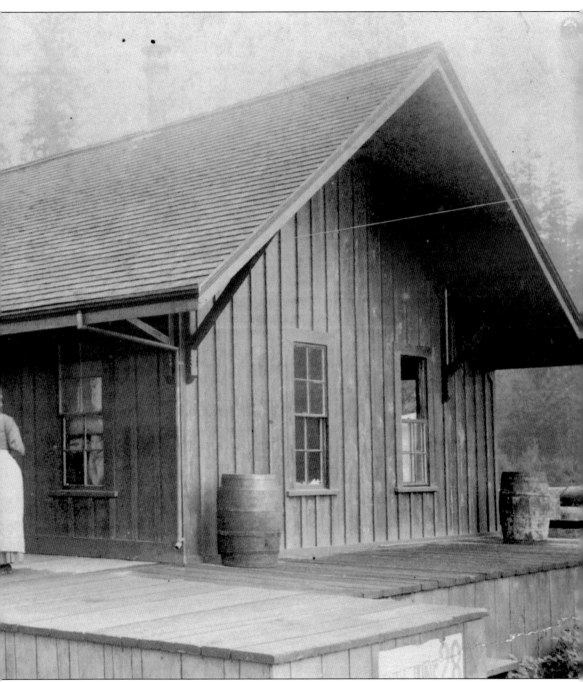

of the Cascade branch of that railroad." Redmond might not have had railroad service in 1888 without his efforts. Trains didn't reach Bellevue until 1904. The railway station was built on land owned by John Luke McRedmond.

James Hoffner was the first station operator at the Redmond Railway station. He sold tickets, operated the telegraph, took care of freight, etc. Before he came there was no telegraph and Urania Farrel Adams sold tickets for about 30 minutes before train times. James Hofner was succeeded as station operator by Andy Lamere who lived at the depot with his wife Augusta.

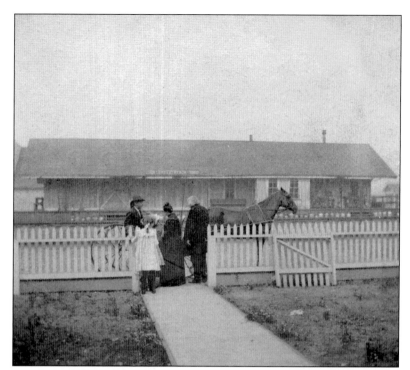

Justice White and Emma are shown here meeting a buggy driver in front of the Hotel Redmond facing the railway depot.

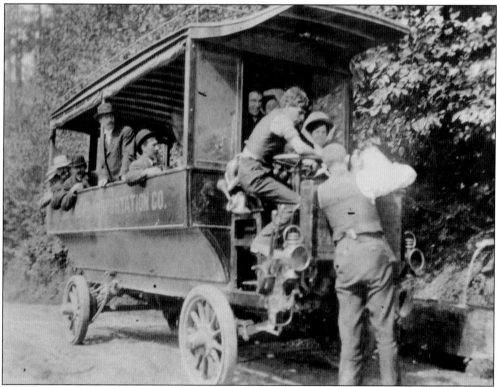

Early automobiles did not have sophisticated cooling systems. Notice the water spring on the right. The driver is adding water to the radiator.

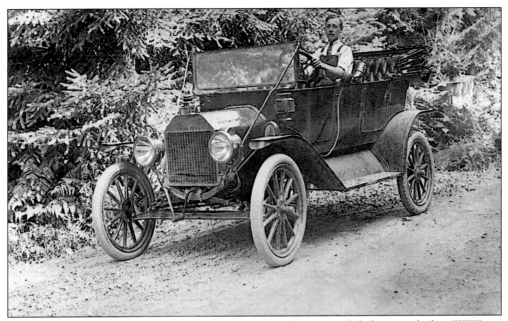

Percy Luke Smith is pictured driving a Ford while in the automobile business before WWI.

According to Kurt E. Armbruster in *Orphan Road: The Railroad comes to Seattle, 1853–1911*: "On April 15, 1885, Thomas Burke and Daniel Gilman incorporated the Seattle Lake Shore & Eastern Railway Company to "build to Spokane and Walla Walla by the Snoqualmie or other available pass . . . and connect with some eastern trunk line," most likely Seattle's favorite Northern Pacific antidote, the Union Pacific. Turning of the first sod and driving of the first piles for the Seattle Lake Shore & Eastern began in April 1887. By April 15, 1888, the rails reached Gilman (now Issaquah)."

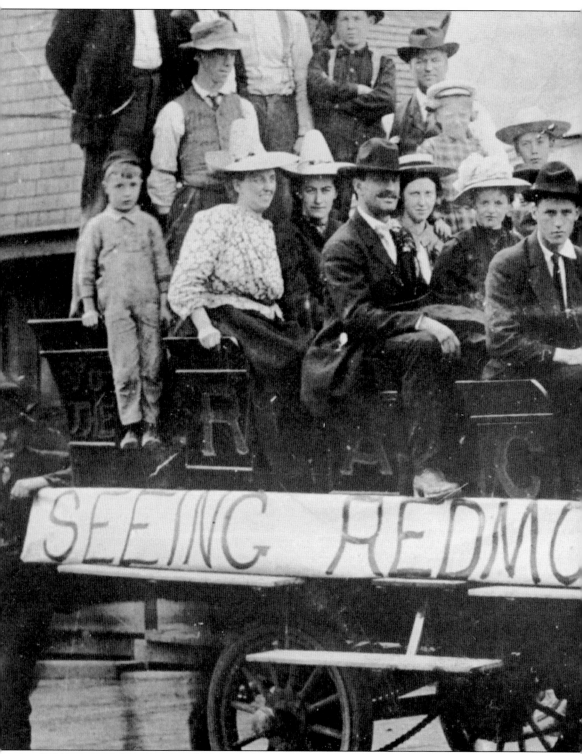

Bill Brown ran this auto stage from a stand in Seattle to the old Meadows Race Track. Originally bought for Redmond-Kirkland travel, he used it on the more lucrative run during the Alaska-

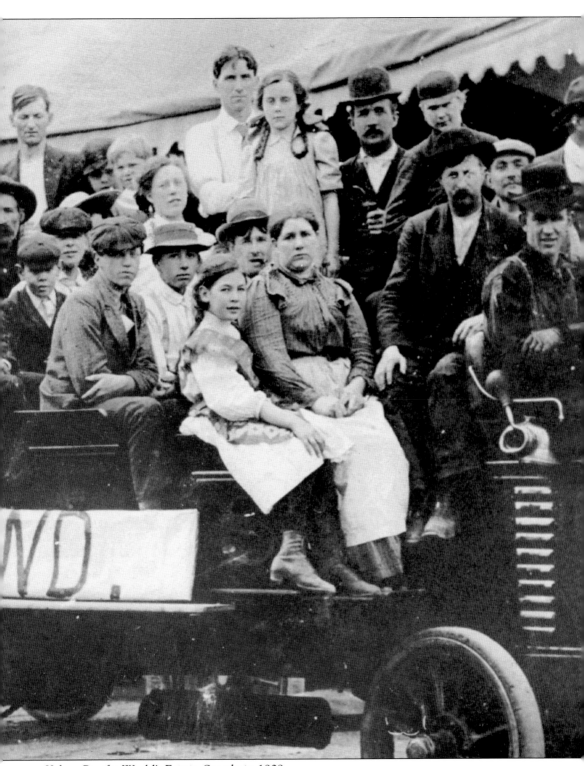

Yukon Pacific World's Fair in Seattle in 1909.

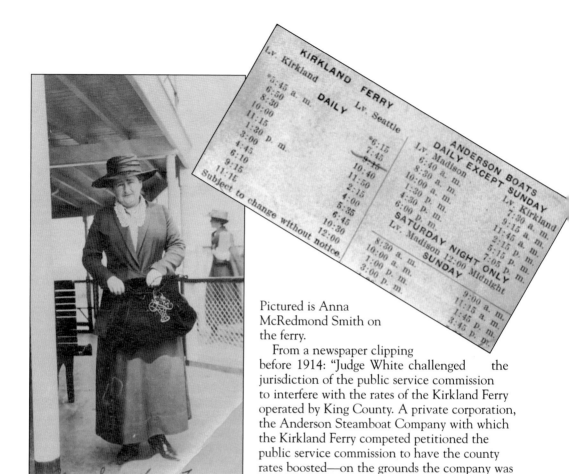

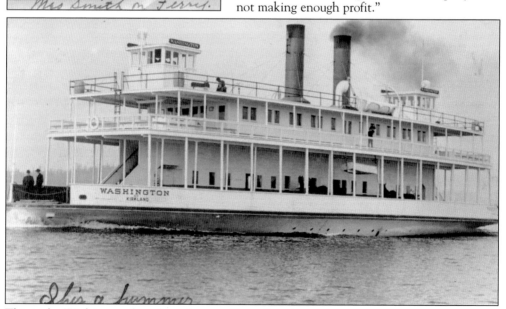

Mrs Smith on Ferry.

Pictured is Anna McRedmond Smith on the ferry.

From a newspaper clipping before 1914: "Judge White challenged the jurisdiction of the public service commission to interfere with the rates of the Kirkland Ferry operated by King County. A private corporation, the Anderson Steamboat Company with which the Kirkland Ferry competed petitioned the public service commission to have the county rates boosted—on the grounds the company was not making enough profit."

This is the Washington ferry from the eastside to Seattle.

Four

SCHOOL HISTORY

In 1871, school age children in what became Redmond were James, William, and John McRedmond. By 1880 there were 11 school age children. *The Daily Intelligencer* quoted Luke McRedmond on September 1, 1876: "A good schoolhouse has been built and school is conducted six months of the year." *The Seattle Times* quoted Anna McRedmond on June 5, 1949: "my father, with five sons and two daughters to educate, got several families together and built a school for them on his property. Miss Mary Condon was hired as teacher. She lived at the McRedmond home." Other early teachers were Mr. Hodges, who taught in 1878 and 1879, C. Dunlap, Mrs. Rightsie, Miss Wittenmeyer, M. Whitehead, Vannie Hawley, Ed Turner, and Dora Adair. It seems possible that Warren Wentworth Perrigo, who had taught school in Kitsap County prior to moving to Redmond, might also have been an early teacher. Warren donated some of his homesite for an early log school house. His brother, William, donated the land Redmond Elementary was built on in 1922.

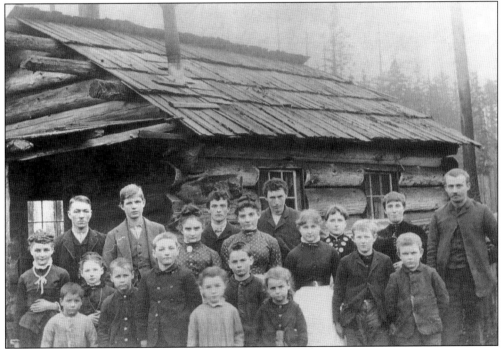

Students at Redmond's Log School in 1887 were, front row, center, Mabel Perrigo, age 7, in the light-color dress, and twin Arlington "Arlie" a little behind Mabel on the right. Robert Perrigo, age 12, is wearing a double-breasted jacket. Marv Perrigo is to his left. DeWhitt Griswold is the second boy from the left in the back row. Additional children include Agnes, 8; Maggie, 11; Jennie, 13; Joe 17; Robert, 20, and Sarah Tosh on the far left; Emma, 18; Dave, 14, and Anna McRedmond, 16; Sam and Dave Perry, 9; Charles William, 10; and Emma Brown. Ed Turner is the teacher.

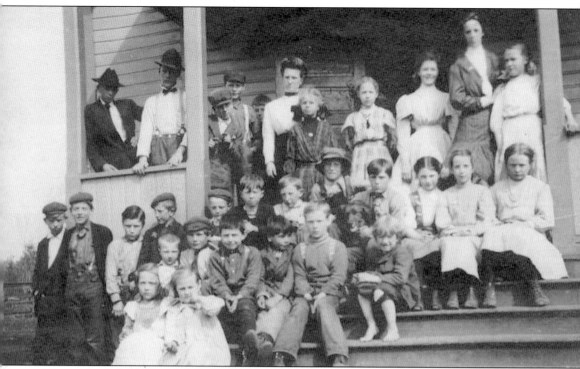

These school children are at Avondale School. Ethel Provan Hebner, author of *Avondale* wrote:

Avondale was beginning to grow. The settlers had named the community but there were several children now, and they must have a school, so in 1895 they took up a collection. Every man in the settlement was asked to give $10; even the bachelors were expected to donate. Judge William H. White donated one-half acre of the land that he bought from Frank Sales for the school. He asked that when the land ceased to be used as a school it be returned to him or his heirs. Then a dispute arose. Some of the settlers in other parts of the community wanted the school placed closer to their homes. The county superintendent Mr. Pusey was called to settle the argument. He held an election, but the vote was tied, so he said he could see no other way than to cast his vote to place the school in the center of the district. Judge White's offer was accepted and work on the new school house was begun. They all worked together until the building was completed. Labor was donated and the leaders found they had enough money to buy a ready-made teacher's desk and about 20 desks for the pupils. These desks were quite a luxury. The new Cottage Lake school had desks made of long benches with another long board higher up to form a desk. Their school house wasn't fancy but cozy.

The first Avondale Teacher was Minnie Ward, who was hired to teach a three months term. This was considered a long school term. Later the school was lengthened to three months in the fall and three in the spring.

The first man to be selected by the Avondale school directors was a man by the name of Wolfington. Some thought that although he was the first man teacher Avondale ever had, he was not the best. The teacher's desk sat on a raised platform in front of the room. As it happened there was a knothole in the floor just to the right of his desk and Mr. Wolfington often spit tobacco juice at this knothole. Sometimes he was successful, but often he missed.

Hattie Griswold was the second teacher, Donna Adair the third. Later followed Mr. Lincolnfelter, Ewing, Annie Nesbitt, and Mr. H. S. Reed, who taught for five years.

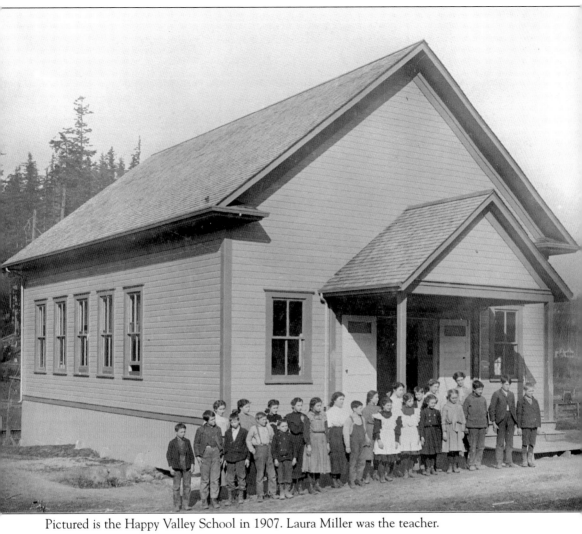

Pictured is the Happy Valley School in 1907. Laura Miller was the teacher.

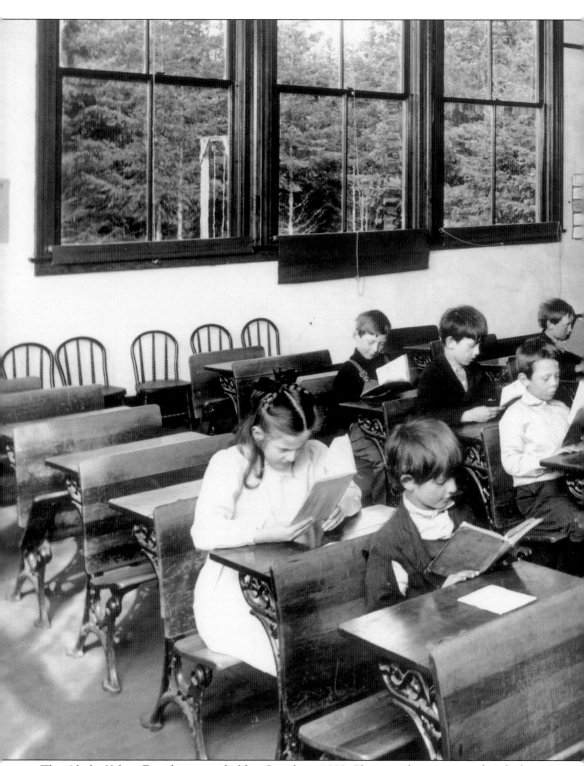

The Alaska-Yukon Expedition was held in Seattle in 1909. Photographers associated with the expedition took photographs of area schools. This photograph is of a class of the Redmond

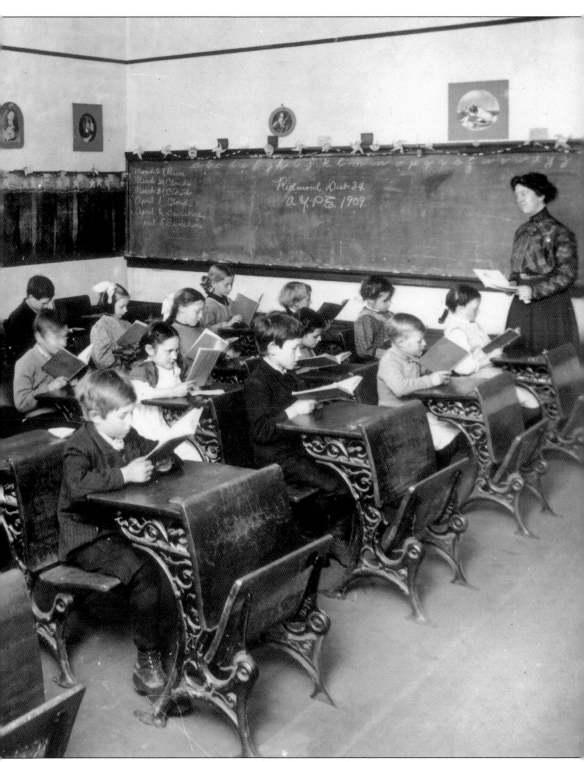

School. Courtesy, MSCUA, University of Washington Libraries, #UW19468.

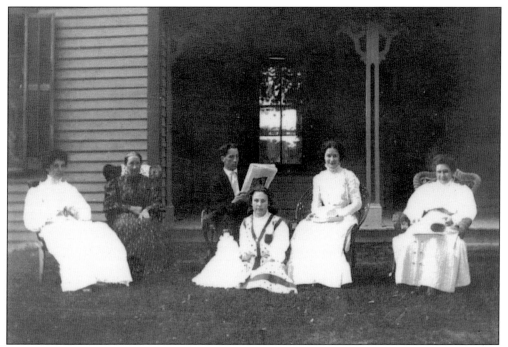

These school teachers in Redmond include Herman S. Reed.

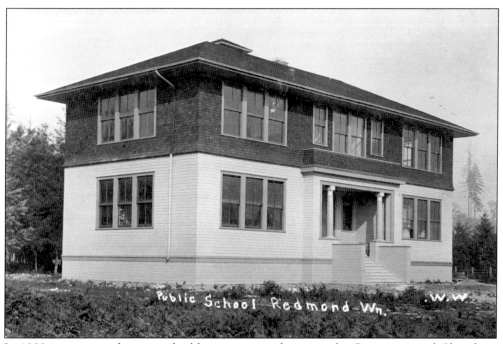

In 1908 a two-story, four-room building was erected next to the Congregational Church in Redmond's Anderson Park. A high school was organized in 1912 and by the spring of 1915, the town had a four-year accredited secondary school. The district was now made up of Inglewood, Avondale, Willows, part of the Highland district, and Redmond. Then came a period of growth and development.

HONOR ROLL OF

REDMOND DISTRICT

Adams, Archie
Adams, Webb
Anderson, John G
Bracken, Earl B
Beba, Julian
Beba, Herman
Beebe, Frank
Beeman, Harry
Chamberlain, George
Chamberlain, Walter
Clark, Will G
Dingwall, Earl
Ditz, Joe
Fanchou, Frank
Hayes, John
Hornall, Tom
Johnson, Ernest
Johnson, Oscar
Johnson, Arthur
Keller, Ralph
Keller, Francis
Kruger, John
Kruger, Olaf
Latimer, Arthur
Major, Frank
Major, Claude
Major, Eddie
Morrison, Ross
Morrison, Edison
Morrison, Joseph
Olsen, Alf
Otterson, James
Otterson, John
Osberg, Arthur
Norman, William A.
Perrigo, Thomas

Perrigo, William
Perrigo, Robert
Poli, John
Ramsey, Edward
Rarick, Henry
Robstad, Albert
Robstad, Hjalmar ★
Sherbeck, Ernest
Sherbeck, Byron
Sherbeck, Jack
Smith, Percy
Smith, Hazel
Getchell, Harmon
Stensland, Halvor
Stensland, Carold
Seidel, Custer ★
Turple, James
Turple, Ransford
Trippet, Maitland
Wallace, Maggie
Wallace, Burley
Wallace, Monte
Wilt, John
Howe, Geo. B.
Isackson, Henry
Trempe, Louis
Swan, Pearl
Swan, Frank
Swanson, Oscar
Alner, Chas
Olson, Andrew
Carlson, Marshall
Stensland, Ben
Weiss, Beno
Scott, L.
Warfield, Alfred

Woodworth, Oliver
Davis, G.A.
Fletcher, M.R.
Koontz, Reuben
Tardy, Edward
Clark, Roy
DeMerritt, Geo.
Eisen, Geo.
Getchell, Stephen
Fowler, Mark
Lyford, Arthur
McKay, Frazer
Partick, Jesse
Pugsley, Ernest
Persina, Felix
Erickson, Sophus
Olson, Martin A.
Rogers, John
Laudadio, James
Herzog, Louis
Ellis, Walter
Routley, Thos.
Rogers, Fred
Rogers, Matthew
Rogers, Manson
Campbell, Ross
Olson, Peter Emil
Krogh, Orley
Krogh, Dallas
Poli, Louise
Mundorff, Lloyd
Brown, John L.
Mitchell, Robert

Redmond Elementary School displayed a list of Redmond-area residents who served in World War I. Hjalmar Robstad and Custer Seidel gave their lives for their country.

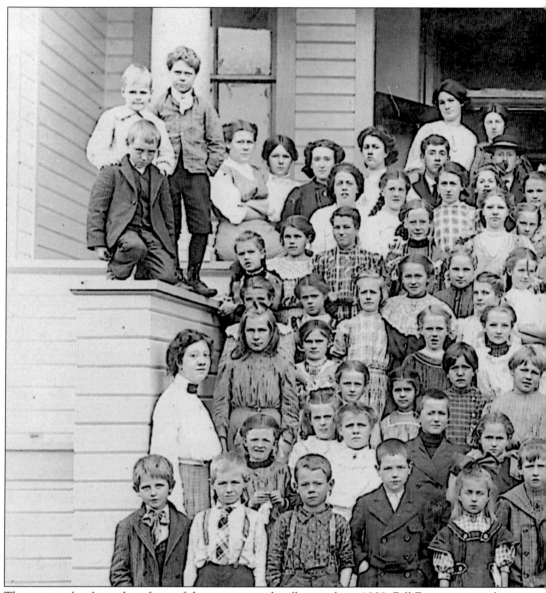

The entire school stands in front of the two-story schoolhouse about 1909. Bill Forrester served as principal during this and the following year with Miss Flora Fremaine, Miss Stark, and Maude McElroy. The students are identified by Stella Rosford Ness on April 20, 1983: (first row) 1) Clarence Perrigo, 2) George Keller, 3) Russell Jaycox, 4) Monte Wallace, 5) Gladys ?, 6) Jerold Munson, 7) Burke Baker, 8) Oliver Woodworth or Woodruff, 9) unidentified, 10) Joe Perrigo, and 11) Orlew Pence; (second row) 12) Mable Connery, 13) Rachel Erickson, 14) Rysnyder ?, 15) unidentified, 16) unidentified, 17) Bobby Perrigo, and 18) unidentified; (third row) 19) Violet Brown, 20) Leon Baker, and 21) Harold Everson; (fourth row) 22) Dora Adams, 23) Hazel Duffy, 24) Rachel von Postal, 25) Alta Bates, 26) Stella Rosford, 27) Gladys Boddy, 28) Mary Anderson, 29) Louise Forrester, and 30) Howard Faulds; (fifth row) 31) Lena Bates, 32) Theresa Graff, 33) Myrtle Taylor, 34) Nettie Carlson, 35) Maud Perrigo, 36) Benno Weiss, 37) John Bloom, and 38) Asel Moore; (sixth row) 39) Sylvia Stitham, 40) Ida Vine, 41) Helen Smith, 42) Susie Rysnyder, and 43) Gladys Munson; (seventh row) 44) Gladys Stitham, 45)

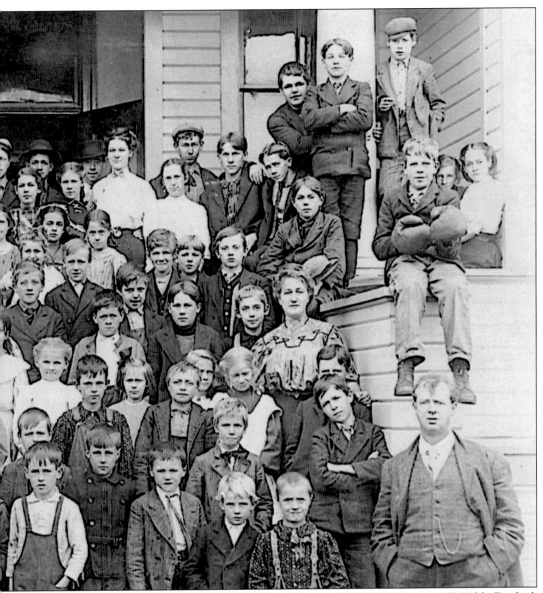

Princess ?, 46) Maggie Wallace, 47) Margaret Bloom, 48) Myrtle Moore, 49) Hilda Rosford, 50) Esther von Postal, 51) Ed Taylor, 52) Martha White, 53) Percy Smith, and 54) Raymond Von Postal, (eighth row) 55) Rena Brown, 56) Beatrice Boddy, 57) Myrtle Duffy, 58) Faye Pence, 59) McKinley Keller, 60) Bill Perrigo, and 61) Homer Taylor; (ninth row) 62) Mildred Hagmoe, 63) Bessie Wallace, 64) Hazel Smith, 65) Vera Morse, 66) Velma Morse, 67) Shirley Gill, 68) Etta Boddy, 69) Ethel Price, 70) Lillian Graff, 71) Myrtle Dingwall, and 72) Ola Williams; (tenth row) 73) Marian Perrigo, 74) ? Norman, 75) Archie Adams, 76) Irene Westby, 77) Allen Westby, 78) Earl Dingwall, 79) John Adams, 80) Faith Brewster, 81) Lionel Sikes, 82) ? Alner, and 83) ? Alner; (on the left side) 84) Clarence Everson, 85) ? Williams, and 86) Elza Vine; (on the right side) 87) Archie von Postal, 88) Tom Perrigo, 89) ? Rysnyder, 90) Ernest Hagmoe, 91) Philip Larsen, 92) Mary Larsen, and 93) Elsie Weiss. The teachers are William Forrestor, Miss Stark, Flora Fremaine, and Maude McElroy.

The site of the old brick school was purchased in 1921 and the first division of 10 rooms was completed in 1922. In 1922 the first school bus in Washington State was designed and built by the high school manual arts teacher, Judd Orr. Each vehicle carried about 90 children who sat on four long benches which ran the length of the bus. He used a chassis from the White Company (later Kenworth Company). The company offered him a job to design school buses, but he turned them down for the security of his teaching position. In 1925, six more rooms and a gymnasium were added.

Schools did not offer the array of after-school activities in the early days. If students missed their bus home, it likely meant they'd have a long walk. Because of this some students didn't have as much interaction with their classmates until later years.

Valuable contributions to history were recorded by Redmond students who interviewed pioneers for school projects, including 1960 and 1962 Redmond Junoir High History Projects, available at King County Library System. Students who created the 1962 history were Steven Caldwell, Sharon Cook, Sharon Curry, Boris Dincov, Coreen Kelly, Rosemary Pearson, Suzie Seymour, and Eileen Watson. They interviewed Mrs. Ottini, A.N. Brown, Laura Brown, Frank Buckley, Judd Orr, Mary Skjarstad, Mr. and Mrs. Gunnar T. Olson, Mr. and Mrs. Bert Stares, Mrs. Lois Tosh, Mrs. Jensen, Mrs. Galley, Mrs. Johnson, Harold Everson, Mrs. Reece, Mr. Harry Cotterill, Mrs. Grace Thomas, and Mr. Rex Swan, Clarence Fullard, and Mrs. Shobert.

The Redmond Grade School presentation of *Cinderella in Flowerland* was held on May 1, 1925, at the high school auditorium. The cast of characters were: Cinderella, (Daisy) Irma Blau; the Proud Sisters (Hollyhock and Tiger Rose) Muriel Sanford and Eleanor Turner; Godmother (Nature) Francis Martin; Bonne Bee (Little Page) Delbert Moore; Butterflies (Charioteers) Dorothy Jane Kirschner and Faye Turner; Robin Red (Princes' Herald) Doris Nelson; Princess Sunshine (of Sunbeam Castle) Harold Johnson; Morning Glory, Valborg Kelly; guests at the ball were Virginia Bechtol as Poppy, Evelyn Sween as Buttercup, Florence Carr as Pansy, Mary Sigel as Daffodil, Ruth Julian as Violet, Georgia Coffman as Sweet Brier, Lillian Stensland as Mignonette, Elaine Merchant as Lilly Bell, Ethel Cotterill as Sweet Pea, and Irene Clasby as Narcissus; the Six Little Sunbeams were Margaret LaMontagne, Eleanor Mahoney, Jane Bechtol, Helen Johnson, Inez Clasby, and Olive Skjarstadt; the Six Little Raindrops were Marshall Dwyer, Daryl Martin, Charles Bechtol, Harlan Rosford, Thomas Magnussen, and Edgar Mahoney; the Frogs were Marshall Dwyer, Billie Hopkins, Louis Norman, Robert Carr, Daryl Martin, Charles Bechtol, Harlan Rosford, Thomas Magnussen, and Edgar Mahoney. (Some of the Raindrops were also Frogs).

Chorus work was put on by children from the second and third grades. Miss Inez Schofield directed several numbers by the high school orchestra. Special lighting effects were obtained from the Moore Theatre of Seattle. Gorgeous costumes and scenery made the playlet a spectacular affair. Much of this information was in the Eastside Journal, April 30, 1925, page 3. Margaret Evers Wiese found the article. Her mother, Ethel Cotterill Evers, was a Sweetpea and is 8th from the left. Ethel's father, Robert Cotterill, was the beloved custodian who was also gifted musically and directed many plays and musical groups. The auditorium has since been renamed in his honor.

Daryl Martin is third from the right with a pointed hat holding a bucket.

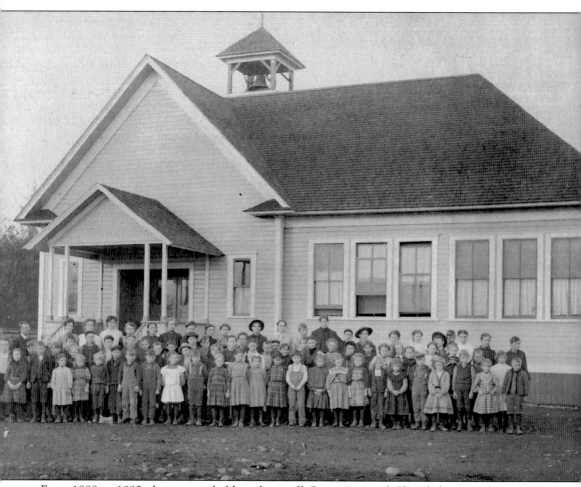

From 1888 to 1892 classes were held in the small Congregational Church because there was no building. This was a trying time. In 1892 the district purchased an acre of ground and erected a one-room building. Things were looking better until a fire destroyed the building in 1895. Workmen got busy and built a new school but tragedy struck again just two weeks before the opening of school when another fire burned the school to the ground. The little church again served as a classroom until another building was erected in 1897. This school was used until 1903. In 1902 the first Union High School, comprised of the Union Hill and Redmond districts, was organized. To accommodate the increased attendance the little church again was used, together with a room added to the school. Three years later this arrangement was disbanded. The year 1904 again found the students crowded into the faithful little church that seemed always ready to assist when the need arose.

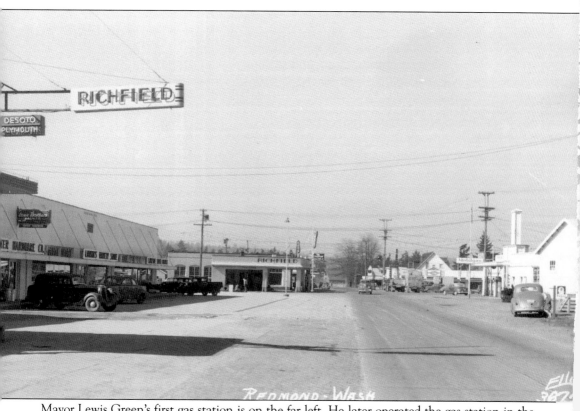

Mayor Lewis Green's first gas station is on the far left. He later operated the gas station in the foreground. Mr. Quakenbush owned the building with Center Hardward and V&B Variety store. Across Redmond Way, you can see the back of the Odd Fellows Hall (now Edwardian Antiques) in the distance.

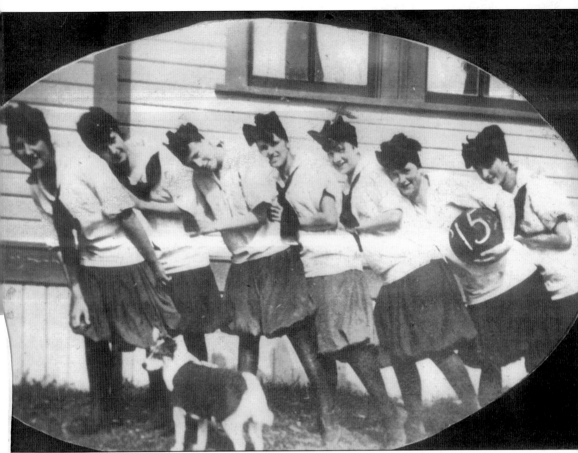

Pictured in 1915 is the Redmond girls' basketball team. A huge photograph of these same girls looking up from the ground has been on a wooden display at the Bear Creek Safeway on Redmond Way for decades. They played by girl's rules.

Elmer Carlberg wrote in the *Sammamish Valley News*, page 4, on December 11, 1952: "Leo Reed tells of C.A. Shinstrom coaching Redmond High School basketball teams from 1914 to 1920, nearly always being in the playoffs and winning the King County Championship in 1918 and having a tie in 1919. Shinstrom would work out diagrams with chalk on the floor of the Redmond Bank for the team. They won the championship from Auburn and the final game was played at the YMCA. The players were Leo Reed, Milo Beck, A.E. Lee, Oliver Woodruff, Earl Coffin, Ted Stensland, Herman Swanberg, and Oscar Johnson."

One of the early boys' basketball teams included Albert Robstad, Ernest Johnson, Tom Perrigo, Ben Stensland, and John Otterson.